People

AMERICAN
IDOL

WHERE
ARE
THEY
NOW?

**ALL 120 FINALISTS FROM
THE FIRST 10 YEARS!**

CONTENTS

ONE GREAT LEAP FOR REALITY TV
Energetic Season 1 winner Kelly Clarkson became the poster girl for *American Idol*'s sudden, and undeniable, impact

THE ID★L

When a new TV show called *American Idol* premiered on June 11, 2002, you had never heard of any of these people. Ten years later, they're everywhere: *Idol* grads have sold nearly 50 million albums; received 37 Grammy nominations (with 9 winners); nabbed an Oscar; and prompted 250 million-plus iTunes downloads and more than 4 *billion* phone-in votes. Some, like Carrie Underwood (*Forbes*-estimated earnings during a recent 12-month stretch: $20 million), have enjoyed monster success; scores—literally, *scores*—of others are still chasing the dream. PEOPLE's *American Idol: Where Are They Now?* catches up with *every* finalist from *Idol*'s first ten years.

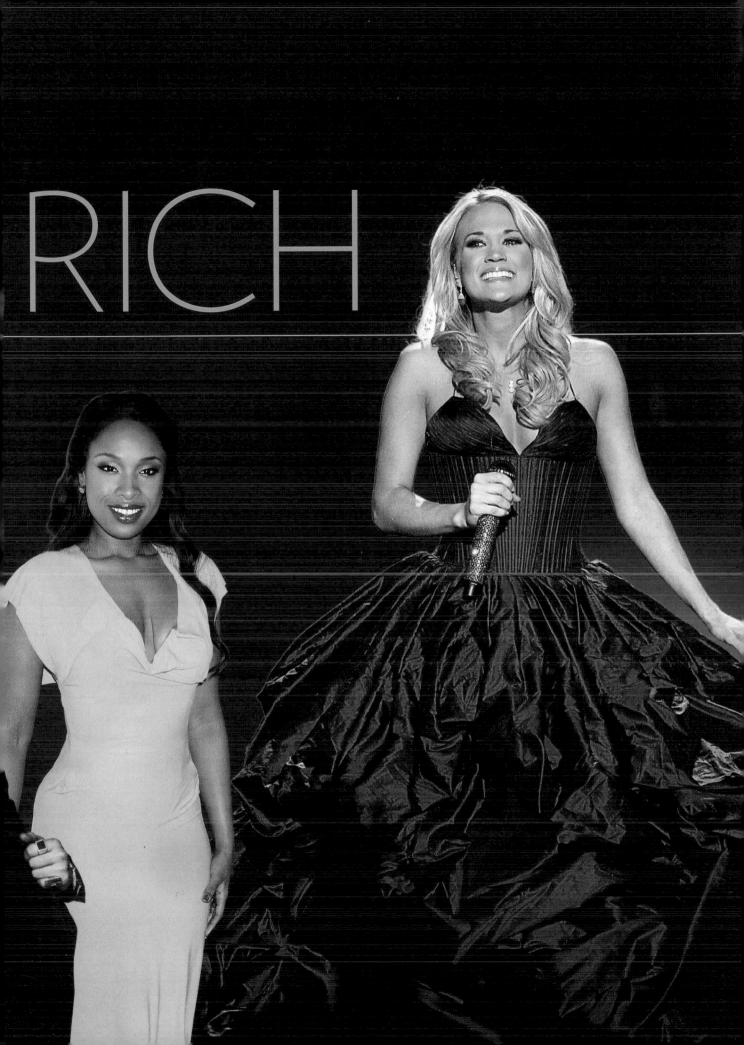

RICH

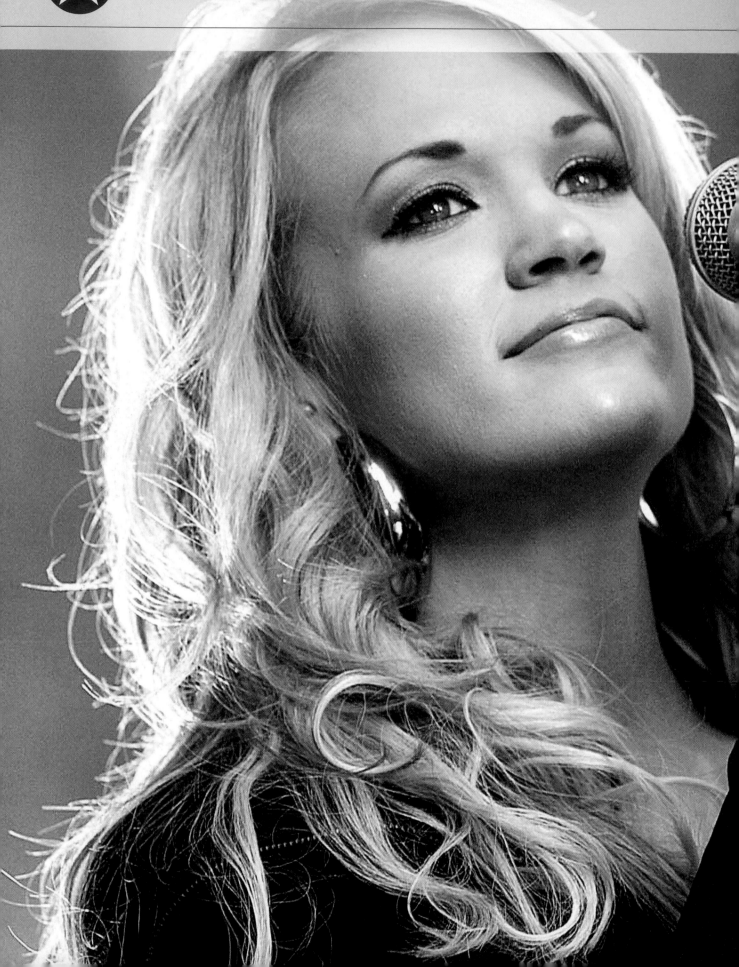

CARRIE UNDERWOOD

Fourteen No. 1 hits; five Grammys; back-to-back Academy of Country Music Entertainer of the Year awards; named Sexiest Female Musician by Victoria's Secret!

Long before *Idol* judges and fans weighed in, Kathy Cooper, Carrie Underwood's elementary school music teacher, had made up her mind. "I wanted to show her off," recalled Cooper, who put Underwood front and center in a fourth-grade musical, "so I had her sing 'Somewhere Out There' from the movie *An American Tail*. She was just so good and wasn't scared at all. She had a big ol' solo and it was just wonderful." For Underwood, who grew up in Checotah, Okla., it was a life-changing moment. "[Cooper's] class was the first

THEN

time I actually got to be onstage and sing by myself," Underwood told PEOPLE. "If she hadn't given me that solo, who knows where I'd be. Maybe nobody would have ever figured it out, including myself."

A little more than 10 years later, millions of *Idol*-ators saw what Cooper had seen. Simon Cowell, weeks before Season 4's final show, went so far as to make a famous—and famously correct—prediction: "Not only will you win this show," Cowell said, "you will sell more records than any other previous *Idol* winner." Indeed, she went on to outsell all subsequent winners as well.

But there's more to success than crowds, cash and Grammys—and Underwood, 29, seems to have found that too. In July 2010 she married hockey player Mike Fisher, now 31, in a flower-filled ceremony at Georgia's Ritz-Carlton Reynolds Plantation. "She found the love of her life," said her makeup artist Melissa Schleicher. "Mike is her Prince Charming."

As the couple sealed their vows, the *other* love of Underwood's life—her rat terrier Ace, dressed in a pink tuxedo—began barking wildly. Simple jealously, said Fisher: "I took his woman." As the evening wore on and a romantic haze spread over the proceedings, Underwood seemed to become, oddly, increasingly patriotic. What was *that* about? "My sister told me if I feel like tearing up, say the Pledge of Allegiance," she said later. "I must have said it 20 times that night!"

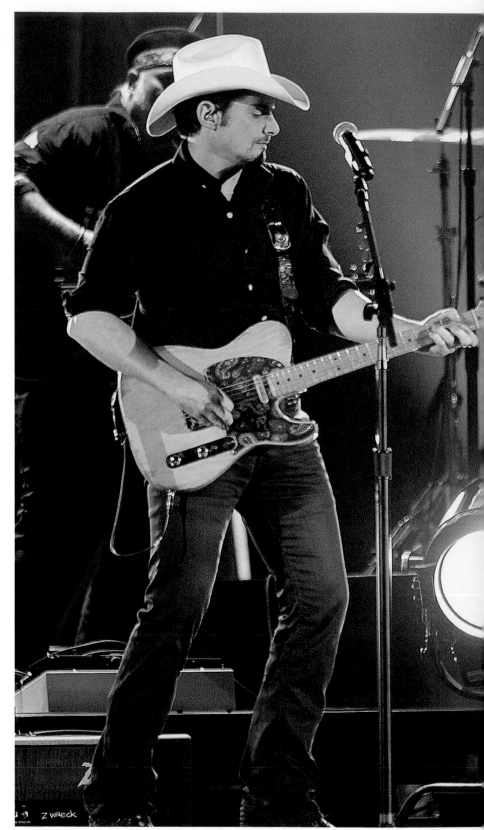

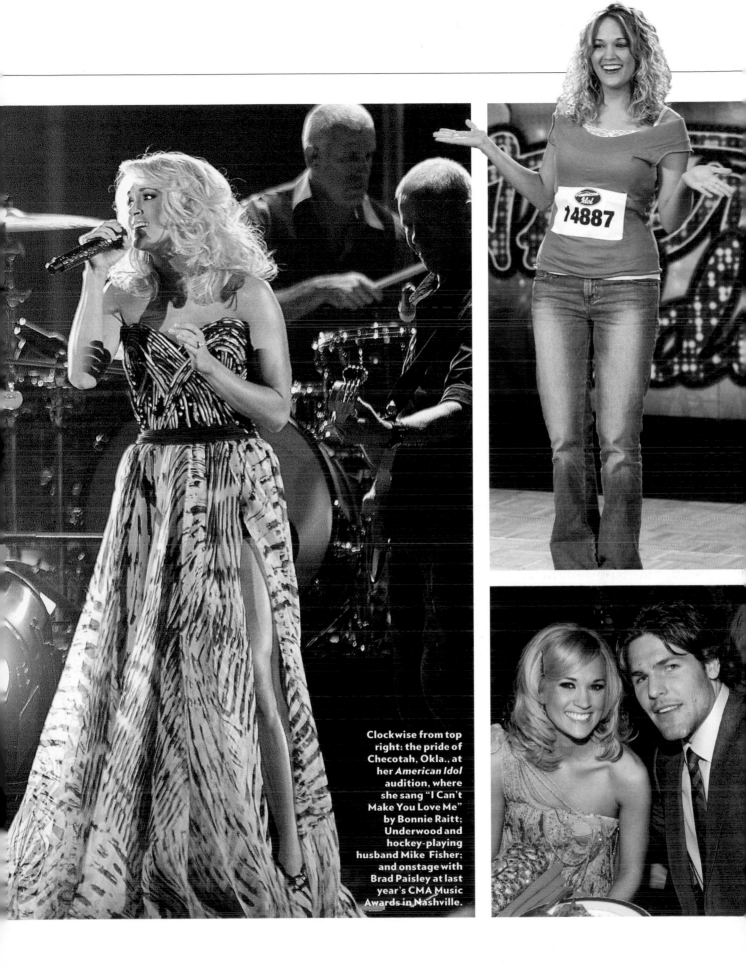

Clockwise from top right: the pride of Checotah, Okla., at her *American Idol* audition, where she sang "I Can't Make You Love Me" by Bonnie Raitt; Underwood and hockey-playing husband Mike Fisher; and onstage with Brad Paisley at last year's CMA Music Awards in Nashville.

KELLY CLARKSON

THEN

AFTER ✪ IDOL
Ten Top-10 singles; 2
Grammys; 30 million-plus
albums and singles sold;
"Since U Been Gone" named
one of the 500 greatest
songs by *Rolling Stone*

Before she set the early bar for *Idol*
success with a string of chart-topping
hits—not to mention a famous shout-
out when Steve Carell screamed her
name during the chest-waxing scene
in *The 40-Year-Old Virgin*—Clarkson
provided the template for the kind
of song-ready backstory that would
become an *Idol* hallmark. Busted flat
as Bobby McGee after a follow-her-
dreams move to Hollywood went bad
early—her new apartment building
burned down the day she moved
in—Clarkson drove back to Burleson,
Texas, prepared to put her musical
ambitions in storage. Then a friend
told her about a new TV talent show
that was holding auditions in Dallas
the next day.

Five months later Clarkson, now 29,
was back in Hollywood, hitting the
jackpot. Her first order of business?
Buying a Corvette for the friend who
aimed her toward *Idol*. "We used to
have to pay for pizza with pennies,"
Clarkson said of her friend, "so it's cool
to be able to give back."

THE **IDOL** RICH

JENNIFER HUDSON

AFTER ✦ IDOL
A Grammy for her first album; an Oscar for her film debut in *Dreamgirls*; TV ubiquity as a Weight Watchers postergirl

Idol fans were outraged when the plus-size diva with the platinum pipes got the boot in Season 3, but Hudson herself wasn't singing the blues. "I'm in good spirits," the Chicago-born bus driver's daughter told PEOPLE. "I'm not discouraged one bit. I know I have a bright future."

She got that right: Before long she had an Oscar and a Grammy (and, in a nice diva touch, two Pomeranian pooches named after the awards).

Tragedy struck in October 2008 when her mother, brother and nephew were brutally murdered in the home Jennifer grew up in. Months of private mourning were followed by a joyful event when Hudson and WWE wrestler David Ortunga welcomed son David Jr. For her favorite role yet she gained 35 lbs. then shed the pregnancy weight in dramatic fashion: The Weight Watchers star spokesperson unveiled a slammin' size 6 figure that caused red carpet double-takes. "People are like, 'You look so familiar … Did I go to school with you?'" Hudson, 29, told PEOPLE. "No one recognizes me anymore." For Hudson, pounds are in the eye of the beholder. "I'm in the best shape of my life," she says, but adds, "I was just as comfortable [before] with my body as I am now."

THEN

CHRIS DAUGHTRY

Two No. 1 albums; four American Music Awards; latest album *Break the Spell* debuts in the Top 10

A Goodyear is a tire; a great year is what Chris Daughtry had in 2006. He had been paying the bills working at a McLeansville, N.C., Honda dealership, hoping that someone would sign his rock band Absent Element. Yet by New Year's Eve 2006, thanks to *Idol*, he was serenading nearly 1 million revelers in New York City's Times Square.

Not bad for a guy who finished fourth. Many handicappers had pegged Daughtry for the No. 1 spot, and Paula Abdul tried to hide tears when he was ousted early. But Daughtry recovered quickly: While the confetti was still raining upon the silver-haired winner, Taylor Hicks, the zero-haired Daughtry, now 32, inked a recording deal, and his eponymously titled debut album sold faster than any debut rock album Soundscan had ever measured. Thanks to *Daughtry*'s quadruple-platinum performance, Chris's album sales have outpaced all other *Idol* runners-up and are exceeded only by winners Carrie Underwood and Kelly Clarkson. *Not* winning, he said "was probably the best thing that ever happened to me."

THEN

36483

AFTER ✪ IDOL
A platinum debut album; a Grammy; starred on Broadway in *The Color Purple*; published a bestselling autobiography—at 21

For Fantasia, the gospel-belting Season 3 champ hailed by Simon Cowell as the greatest *Idol* contestant of them all, the win included a Truth or Consequences moment: "When I won the car on *Idol* I was filled with joy, pride and the fear of someone finding out that I couldn't drive," she wrote in her bestselling 2005 memoir, *Life Is Not a Fairy Tale,* in which the teenage single mom revealed she had been a rape victim at 15, suffered debilitating self-image fears and was a functioning illiterate who couldn't read song lyrics—or the questions on a driver's test. "I was afraid they would take the car away."

Dramatic ups, and stark downs, have continued in her post-*Idol* life. Fantasia's first single, "I Believe," debuted at No. 1, her first album went platinum and she starred on Broadway in *The Color Purple*. Offstage, financial setbacks, a throat injury and a fraught relationship with a real estate agent were followed by her hospitalization for a suicide attempt. Last December, Fantasia, 27, gave birth to a boy, Dallas (she has not named the father).

She vows to ride the waves. When she was hospitalized, she said, "I looked up artists who've been through things, artists who sing from their soul. I took my cues from them, and I just put my mind and everything into music."

FANTASIA

THEN

AFTER ✪ IDOL
Found gold with her first CD; strutted to country music success with the single "Red High Heels"

It was the kind of wedding—at sunset on the Caribbean island of Antigua on Jan. 1, 2011—that some little girls dream about. But not Kellie Pickler, who says that growing up she didn't believe she was "going to get married and didn't believe in love." Her mom abandoned her at 2, and her dad spent much of her childhood behind bars. Pickler, who at one point made $2.50 an hour as a roller-skating waitress, was not suffused with optimism.

And then—boy howdy!—things turned around. Her great voice and homespun humor charmed *Idol* viewers, earning her sixth place in Season 5. And she met a Nice Young Man. "I didn't know someone like Kyle existed," Pickler told PEOPLE of her guy, Nashville songwriter Kyle Jacobs, 38, who does things like leave Post-it Notes around the house that read, "Baby, I'm proud to be your husband. Love you unconditionally." They were in the midst of planning a big wedding when, she says, they realized "that's not us" and eloped. As their private, beachside I do's approached, she ran toward him "as fast as a girl in a wedding dress can go," recalled Jacobs. "She was the most beautiful thing I had ever seen. I kissed her before I was supposed to."

Married and performing some 80 gigs a year, Pickler, 25, is a lot more optimistic nowadays. "I got blessed," she says.

KELLIE PICKLER

THEN

61615

THE **IDOL** RICH

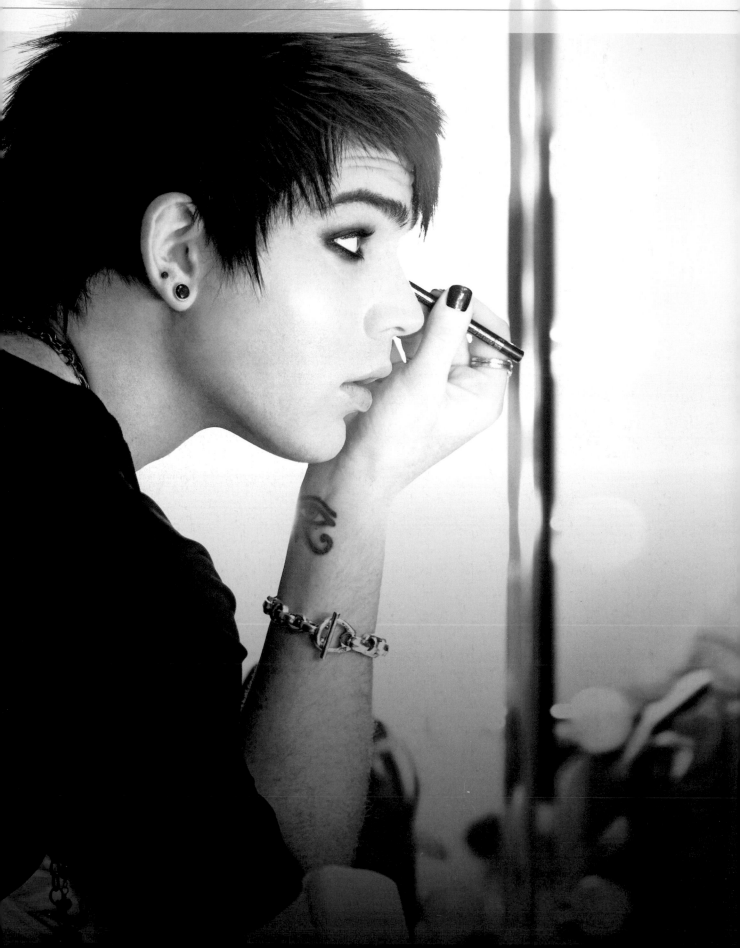

ADAM LAMBERT

AFTER ★ IDOL

Four million singles and more than a million albums sold make this Season No. 8 finisher one of *Idol*'s winningest losers

From the moment he performed "Bohemian Rhapsody" as his *Idol* audition, it was clear Adam Lambert was made to emote. And get people out of their seats: After his rendition of "The Tracks of My Tears," none other than Smokey Robinson, the song's lead singer and an *Idol* mentor, stood and applauded, and Lambert's number got a standing-O even from Savage Simon, who earlier dissed the man-in-black-eyeliner's version of "Ring of Fire" as "indulgent rubbish." Another class moment: When the heavily favored Lambert came in second, and winner Kris Allen told the audience, "Adam deserved this."

His post-*Idol* career has combined concerts and controversy: Viewers protested loudly when Lambert, during the 2009 American Music Awards, seemed to simulate oral sex with a band member. He told Ellen Degeneres that he "maybe went a little bit too far," but Lambert made no apologies for who he is. "I am flamboyant," he said. "I am gay. And I don't think there's anything wrong with that."

THEN

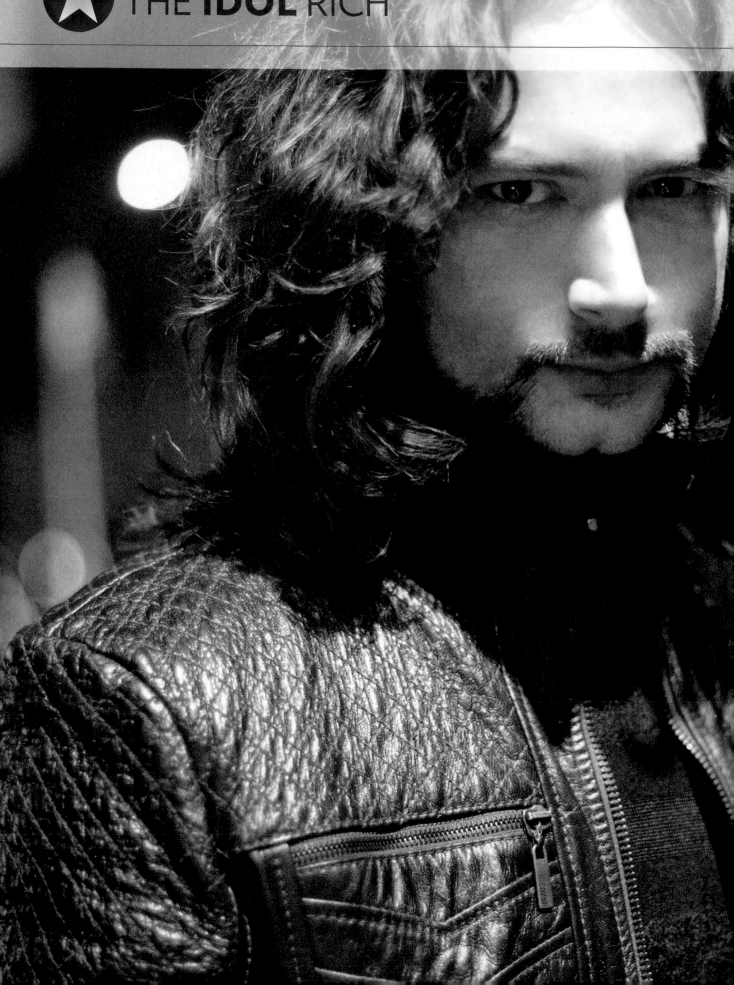

CONSTANTINE MAROULIS

THEN

AFTER ✦ IDOL

A Tony Award nomination for Broadway's *Rock of Ages*; a role in the movie; starring in the upcoming musical *Jekyll & Hyde*

Sixth place, fourth season—and still going strong. "I meet people every day who say 'You should've won!'" Maroulis, 36, says of his locks-loving fans. Even after his debut album flopped (25,000 copies sold), he wouldn't stop believin', vowing, "I'm gonna keep rockin'." But *differently*: First came a spot in the touring company of the Broadway musical *The Wedding Singer.* Then he landed the role a New Jersey-born rocker, weaned on Bon Jovi, was born to play: the lead in *Rock of Ages*, the hit musical inspired by the bombastic hair-metal bands of the '80s. A Boston Conservatory-trained musician, Maroulis proved on *Idol* that he had the chops to perform *Rock of Ages* tunes by the likes of Poison, Guns 'N' Roses, Journey and (who can forget?) Whitesnake. As for how he preps his trademark tresses for their hair-metal moment, the singer told ENTERTAINMENT WEEKLY: "You just let it dry—and let it rock!"

SCOTTY McCREERY

AFTER ⊙ IDOL
First album, *Clear as Day*, went platinum

How powerful is the pop from *Idol*? The newest, country-est winner is only the latest to accomplish something impossible in the pre-*Idol* world of Elvis, the Beatles and Michael Jackson: His *debut* album debuted at No. 1 on Billboard's Top 200.

So how was your year, Scotty? "Insane! We had the show and when we got off we hit the ground running," says McCreery, 18 and still a senior at Garner Magnet High School in Garner, N.C. He is, astonishingly, balancing touring with homework. "I haven't lost sight of where I come from," he says. "I like having the best of both worlds. As long as I get my homework in, I can keep doing it." Fan recognition is still "a shock," as was the offer from Brad Paisley to come on tour as his opening act. "I said, 'Are you kidding me?' I was really nervous and shy until we shook hands and said hi. Once I realized he was a great guy, I was really comfortable around him." That said, he's mostly still a kid in a very big candy store. "I'm still the newbie in Nashville," says McCreery, who rubbed shoulders with Kenny Chesney, Keith Urban and Taylor Swift at the CMA Awards. "I'm that country-music fan that gets all giddy when I'm around those people."

KATHARINE McPHEE

AFTER ✪ IDOL
A starring role in NBC's big-budget Broadway drama, *Smash*

The Season 5 runner-up (to Taylor Hicks) says she's learned a lot about the business since then. Her classically trained voice and *Idol* popularity helped her debut album reach No. 2, but her 2010 follow-up, *Unbroken*, failed to ignite. She *almost* landed the bride role in *The Hangover*, scored a small part in the film *House Bunny*, and hit the jackpot as the small-town girl with Broadway dreams in NBC's heavily promoted *Smash*. "I could just *so* relate to this girl," says McPhee, 28. "All the doors shut in my face. She's just like 'Let me show you what I can do.'" Although many critics liked the show, ratings have been iffy. Whatever the future, McPhee will likely keep pushing: "I feel like a different person than I was after *Idol*," she says. "I get the celebrity game now—you can go from being hot to fighting to be seen."

RUBEN STUDDARD

AFTER ✪ IDOL
One million copies of his debut CD, *Soulful*, were ordered before its official release date, confirming *Idol*'s power to create instant stars

Fans called him the Velvet Teddy Bear for his smooth vocal style and his big-as-a-grizzly stage presence. An Army brat born in Frankfurt, Germany, Studdard grew up in Birmingham, Ala., where he tipped the scales, as well as sang them, at an early age. Though weight-related health problems including high blood pressure, heart disease and diabetes ran in his family, he turned his size to his advantage, starring as an offensive lineman on his high school football team and earning an athletic scholarship to Alabama A&M, where he majored in music and dreamed of becoming an opera singer. But when he weighed in at a dangerous 455 lbs. a few years after his *Idol* win, Studdard began a no-meat-diet-and-exercise binge that helped him shed 70 lbs. Now a weight-loss evangelical who helped sponsor a Scale Back Alabama challenge in his home state—where overweight Alabamans pledged to shed a collective total of 10 million lbs.—Studdard, 33, whose own goal is a hard-to-attain, svelte-for-him 250 lbs., trusts fans will still swoon at his velvet vocals, even if there is less Teddy Bear to cuddle.

CLAY AIKEN

Five million albums sold; his own NBC Christmas special; a Broadway role in *Spamalot*; due soon on *Celebrity Apprentice*

Triumph, tribulations, triumph: It has been a whirlwind cycle for Aiken, a self-described "dork" who was nonetheless a nerd who deserved to be heard. When the 24-year-old North Carolina college student opened his mouth, a legion of achin'-for-Aiken female fans was born. He lost by a whisker to pal Ruben Studdard and later suffered panic attacks brought about by sudden fame, but fanatic and faithful Claymate fans stood by him, snapping up CDs and filling concert seats.

Then came a personal crisis. After years of denying his sexuality to himself, family and friends, he came out in 2004 in an emotional confession to his mother; four years later he went public in PEOPLE. The impetus to do so, he said, was also his greatest joy: the 2008 birth of his son Parker, via artificial insemination with a longtime friend. "It was the first decision I made as a father," Aiken told PEOPLE. "I cannot raise a child to lie or to hide things. I wasn't raised that way and I'm not going to raise a child to do that." As for the littlest Claymate, his proud pop, now 33, says there's no runner-up. "[My] mom looked at me when he was born and said, 'You never thought you could love anything this much, did you?' And I realize what she meant."

THE
A-TEAM

In the beginning, there were some people you had never heard of, and Paula Abdul. What a difference a decade makes

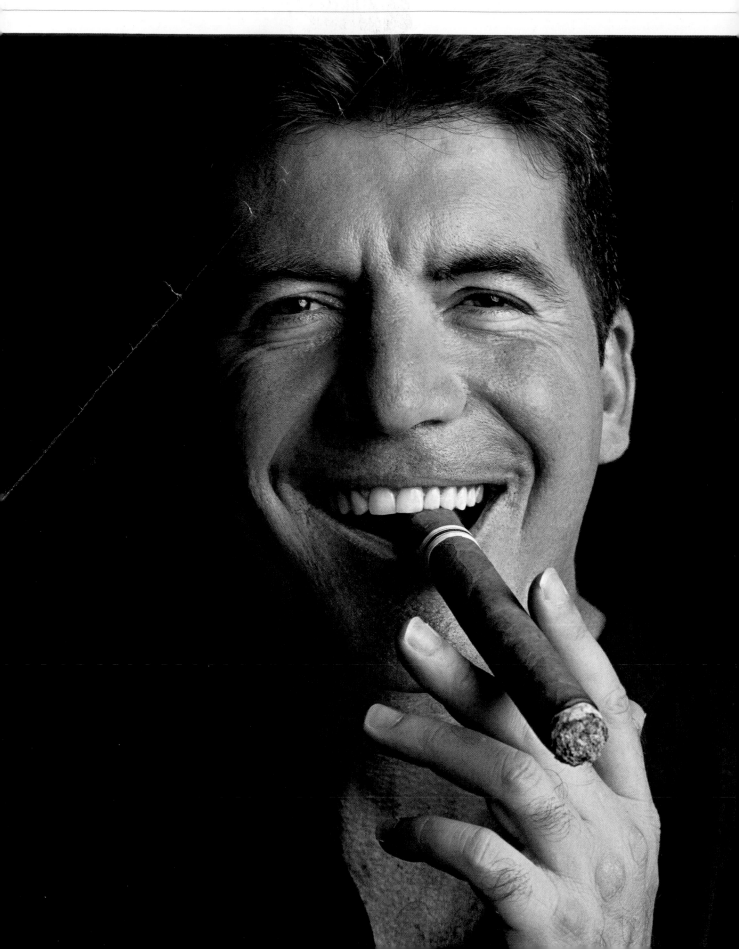

SIMON

Others might hesitate to say a singer's voice "sounded like cats jumping off the Empire State Building," but *Idol*'s sharp-tongued Solon loved making the fur fly

"Nasty Simon" must have been warned the put-downs that made his name on Britain's massively popular *Pop Idol* might not fly in the Colonies. Apparently he wasn't listening. On his first cross-country audition trek in the U.S., "he actually said to somebody, 'You're too fat,'" recalled Nigel Lythgoe, the *AI* executive producer (and a *So You Think You Can Dance* judge). "The American crew nearly passed out."

Many were still gasping on this side of the Atlantic long after the transplanted *Idol* scored its spectacular success. "We've had some shockingly bad people this year," Cowell said in 2008 of some who bled from his cut-to-the-quick judgements. "What's amazing is how much they believe that they're right and I'm wrong. And they get more argumentative with me—and all I'm trying to do is help them." The son of a music industry executive, Simon says he started helping others see the truth—as he saw it—at age 4 when he told his mum that her white pillbox hat made her look like a poodle. "I always thought of myself," he told PEOPLE, "as more funny than unpleasant."

Cowell's heavily promoted new show *The X Factor*—which he said would be a "disappointment" if it didn't draw 20 million viewers—averaged a good-but-not-great 12 million. Three judges—including Paula Abdul—were axed by the end of the first season.

YOU'VE BEEN SIMONIZED!

A buzz saw with a British accent, he sliced and diced to viewers' (sometimes reluctant) delight

" You look like the Incredible Hulk's wife"

" There was a certain irony to you screeching out 'You're no good, you're no good, you're no good' over and over again"

" Can I ask you a question? Do you and your girlfriend sing together at home? Have the police ever called?"

" You sound like a cat in a vacuum cleaner"

" To a hopeful who told a sad story about his wife leaving him: "I'm tempted to ask if you sang that the night before your wife left you"

" It would be rather like ordering a guard dog for your home and getting delivered a poodle in a leather jacket. It's not the real thing"

" I could sell you as a sleeping aid"

"If you win this competition, we will have failed"

"Let me use a horoscope analogy...you and your suitcase will be on a plane within twenty-four hours"

PAULA

Empathetic and unapologetically emotional, she added more than a soupçon of unpredictability to *American Idol*'s weird, watchable alchemy

"No one is entitled to crush dreams," a stressed Paula Abdul told Entertainment Weekly shortly before the 2002 premiere of a long-shot TV talent contest then called *American Idol: The Search for a Superstar*. A former wannabe herself who had risked dream-stomping on her way to becoming a song-and-dance superstar, Abdul was shaken from a month of auditions that required her and her fellow judges to dash the hopes of hundreds whose visions of fame exceeded their talent. "But," she added, nearly overcome by the emotion that would be her hallmark, "it's our job to be honest."

Once *Idol* launched—and soared—Abdul mostly left the dream-dashing to *Idol*'s brush-cut Voldemort, Simon Cowell. While he reveled in the role—and boosted ratings—the onetime Laker Girl played cheerleader, doling out praise and keeping her criticisms kindly. As the sweet see to Simon's saw, she bent over backwards, she told People, "to keep kids' dreams alive." That inspired some odd verbal contortions ("I want to squish you, squeeze your head off and dangle you from my rearview mirror") and nurturing advice that drew on her own struggles. "I may not be the best," she said, "but I have the ability to make the best of what I've got."

And Abdul, who left *Idol* in 2009, may have revealed a hidden talent for predicting the future when, in 2002, she described *Idol* as a search for that "undeniable, undefinable 'X factor.'" Last year, she joined Simon on his new show *X Factor*—but, in an ironic twist, was voted off by producers before the second season.

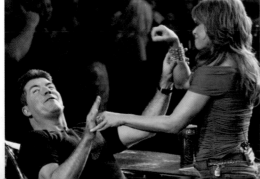

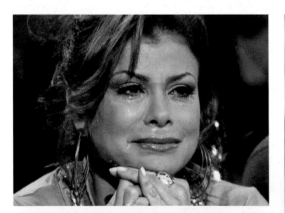

"I get p----d at him," said Abdul of her alternating fondness for and exasperation with Cowell, who often seemed gleeful when ripping her faves. "Sometimes I punch him. He says he has permanent bruises." Cowell, in a 2002 insult swap: "There are days I cannot stand to be in the same room with her." Abdul: "Is there anything I like about Simon? Yes: When he goes to London."

RYAN

SEACREST

His own idols—Dick Clark and Merv Griffin—inspired him to become a wiz at the biz as well as the show. But the busy host and producer (*America's Top 40*; *Keeping Up with the Kardashians*) never lets his lucrative mogul duties dim his dimpled and painstakingly maintained *Idol* glow. "I was like, 'Guys don't do this,'" the admitted metrosexual says of his "strategically tousled hair," waxed eyebrows and frequent facials. "Now I'm addicted!"

RANDY

JACKSON
Listen Up, Canine!

As Noah Wyle was to *ER*, so Randy Jackson is to *American Idol*: The last survivor— among the judges—of an original ensemble cast. To what to attribute his longevity? Professional cred? Sure. Nice glasses? Of course! But more than anything, the man projects animal instinct. And we're talking about one animal in particular: If you don't know how to do it, he'll show you how to talk the *dawg*. Some (of his very, very many) samples of pooches as pronouns:

66 Yo, yo, yo, dawg!"

66 It was dope, it was crazy. I want to call Maxwell and tell him, 'Yo, Big Mike is knocking on the door, dawg!'"

66 I'm sorry, dawg, it just didn't work for me"

66 What's up, dawg?"

66 Yo, dawg, there's some good stuff and some bad stuff... Check it out, dawg."

66 Talk to me, dawg... How do you think you did?

66 Yo, let me start off by saying, dude, I like the cardigan though. I like you rocking The Dawg's look. I like that!"

66 It was just awright for me, dawg. You know what I mean? I mean it wasn't great, dawg ... You gotta bring it next week, dawg"

WHERE ARE THEY NOW?

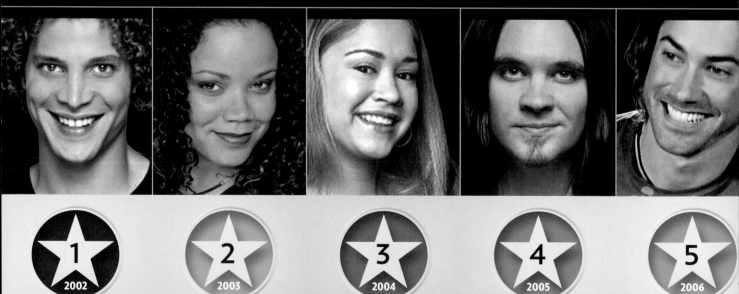

1 2002
2 2003
3 2004
4 2005
5 2006

One sings on cruise ships; one's a hairdresser; there's a *very* hot Season 3/Season 5 romance afoot; at least five have had run-ins with the law, and two appeared on *Celebrity Rehab with Dr. Drew*; and, based on the evidence, it's hard to imagine how road shows of *Rent, Hair* and *Joseph and the Amazing Technicolor Dreamcoat* ever got onstage before there was idle *Idol* talent available.

Ten years after *American Idol's* June 11, 2002 premiere, 120 finalists have been loosed upon the world. Some—like Carrie Underwood, Kelly Clarkson, Chris Daughtry and Katharine McPhee—have gone mega. Others, including Season 5's Ace Young and Season 6 winner Jordin Sparks, have built solid careers. Almost every finalist has released an album (or is working on one), and only a handful have put music on the back burner. For everyone else, as becomes clear in the following pages, the song remains the same: They're plowing ahead, eye on the prize, aware that stardom is just a hit away.

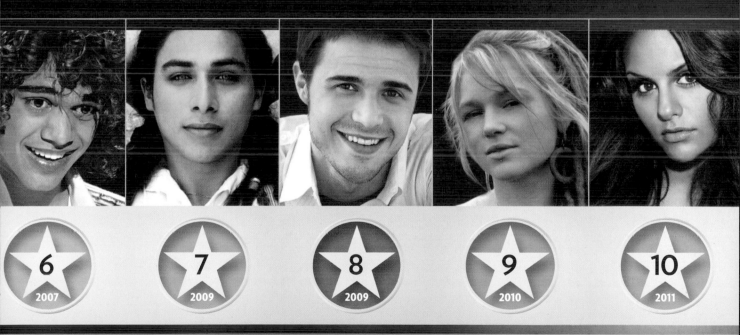

6 2007 7 2009 8 2009 9 2010 10 2011

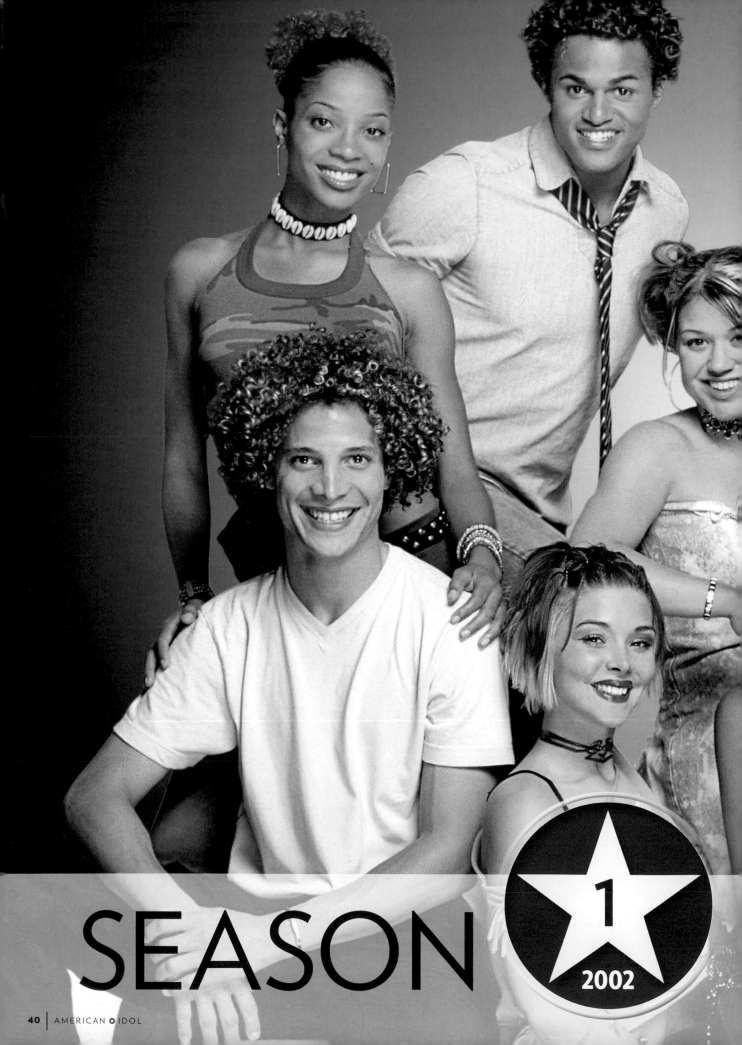

SEASON

★ 1
2002

What a curious cocktail: Combine singer Paula Abdul; record producer Randy Jackson; an acerbic Britwit, Simon Cowell; and 10 wannabe pop stars. Stir for eight weeks. The result? A TV juggernaut, and an instant megacareer for former Texas cocktail waitress Kelly Clarkson, 20 (see page 10)

(see page 10)

SEASON

JUSTIN GUARINI

Idol's first Teen Idol has trimmed his trademark curls (say it ain't so!) but only increased his strength: Most notably, he landed on Broadway playing Patti LuPone's son in *Women on the Verge of a Nervous Breakdown* in 2010 and, a year later, starred in *American Idiot*. Next up: the world premiere, in Atlanta, of *The Ghost Brothers of Darkland County*, a musical with book by Stephen King, songs by John Mellencamp. "It's so crazy and awesome, I can't even begin to tell you," says Guarini, 33. A father of two, living in Doylestown, Pa., he realizes he owes a lot to *Idol*: "I look at it as the catalyst for everything I've done since and everything I will do in the future. It's wonderful."

NIKKI McKIBBIN

Season 1's No. 3 finisher had a rough road after *Idol*, turning up on *Celebrity Rehab with Dr. Drew* and its spin-off, *Sober House*. Now she's nearly four years sober (though she still wears a tongue stud that looks like a pill: "It freaks people out!"). Married for nearly five years to a tech guy, she fronts her rock band No Rest for the Wicked and says she has dropped all of the 135 lbs. she gained while battling addiction. "When they put me on one medication, I gained 33 lbs. in a month," says McKibbin, 33. "I never thought I'd be small again."

KNOW YOUR J S

R.J. Helton **a**

A.J. Gil **b**

EJay Day **c**

a

b — In 2002

c — In 2002

IDOL'S TENTH-LETTER MEN

R.J. Helton, who pursued a Christian music career, lost everything in Hurricane Katrina. He later came out of the closet ("Just because I am gay does not mean I can't love God") and moved to San Francisco, where he sings in clubs. A.J. Gil went broke after *Idol*—he blames bad management—wound up living in his car, and, he says, eventually "cried out to God." He performs Christian music and recently married. EJay Day has performed for a decade on cruise ships. "Being an entertainer on ships is pretty good," says Day. "The only downfall is that you are far away from family and connections. But I can't complain—I'm doing what I love."

RYAN STARR

The ab-fabulous rocker (her bare midriff brought an offer from *Playboy*) has been a reality show staple and modeled for Harley-Davidson. But her new fave gig, doing vocals for deejays, keeps her bouncing from L.A. to Amsterdam to Bali. "It's fun because each deejay wants a totally different sound," says Starr, 29. "I get to be a chameleon!"

TAMYRA GRAY
She married former Color Me Badd ("I Wanna Sex You Up") singer Sam Watters in 2006 on the Isle of Capri; they had a daughter, Sienna Marie, in 2010. Gray, 32, has appeared on Broadway in *Rent* and *Bombay Dreams*, and released an album, *The Dreamer*, in 2004.

CHRISTINA CHRISTIAN
Now married with a third child on the way, she quit the music business to have normal hours: "I was not going to sacrifice my family for my career." She got her degree and landed a "nice 9-to-5 job" as a tech recruiter.

JIM VERRAROS
The nerdy-cute ninth-place finisher put out two albums and had a dance hit with "You Turn It On." Then he turned off the music: Verraros, 29, and longtime boyfriend Bill Brennan, 45, wed in 2009 (they made it legal two years later) and now run a luxury bridal business in Chicago.

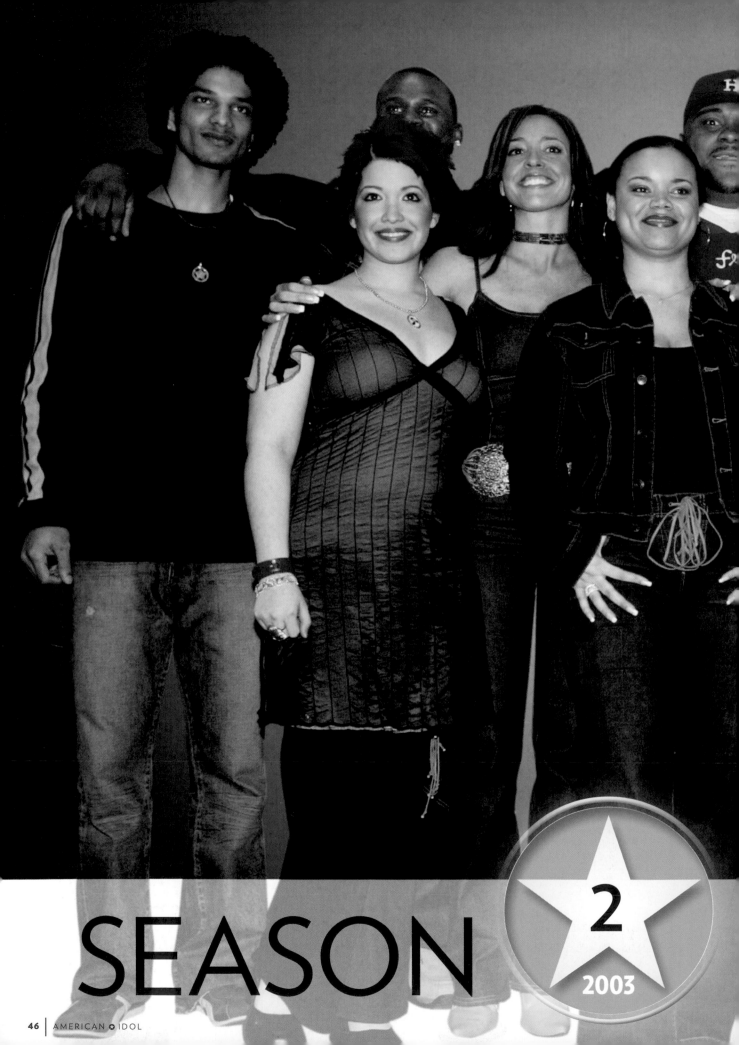

SEASON

2
2003

With *Idol* now a monster hit, millions watched Season 2 come down to a tight race between odd-couple pals Ruben Studdard (see page 26) and Clay Aiken (page 27), then 24, a University of North Carolina student who'd never been onstage. On the final night, with 24 million votes tallied, the Big Man won by 0.56 percent

KIMBERLEY LOCKE

Known on *Idol* as the R&B belter who came in third behind Ruben and Clay, Locke had a hit out of the gate with the song "8th World Wonder." After that her résumé is a mosaic: Locke, now 34, became a plus-size Ford model; worked as a guest host on *The View*; and appeared on VH1's *Celebrity Fit Club*, where she eventually achieved her goal of losing 40 lbs. That led to a job as a spokeswoman for Jenny Craig and a new view about her health. "It's a lifestyle," says Locke, who still makes music but is also getting work as an actress. "Every day, you have to schedule the time. Being on the road will wreck your diet in two seconds, and if you're not prepared mentally, you don't stand a chance."

JOSH GRACIN

Season 2's Singin' Marine—the guy who ended songs with a salute and challenged Simon to a push-up contest—is out of the service (he was honorably discharged in 2004) and out on the road, performing with his band. Although he says *Idol* was "definitely a great experience," he realizes, looking back, that "I was out of my element. I never sang on a stage before. I would be the first to tell you I wasn't perfect." With road work, he says, has come confidence: "Now I'm all over the stage. I am very high-energy, very engaged with the crowd, throwing drumsticks and having a good time."

The father of four (Gracin; wife Ann Marie; and kids Briana, 10; Landon, 6; Gabriella, 5; and Isabella, 3, make their home near Nashville) began his post-*Idol* career with a bang: His self-titled debut album went gold in 2005. When his second album faltered, he was dropped from his label and has since then determined to be his own driving force. "If you keep your head above water, and keep moving forward and being persistent, there's always a place for you," he says.

"I think some of the biggest artists of today—Aerosmith, Kenny Chesney, Tim McGraw—took their lumps and kept on moving no matter what. That separates you from the flashes-in-the-pan." Gracin, 31, released his third album, *Redemption*, in November 2011.

TRENYCE

The feats of Clay and Ruben caused the biggest commotion, but Lashundra Trenyce Cobbins (she goes by just her middle name) still managed a career with legs. She sang and danced on Broadway in *Dreamgirls* and *Ain't Misbehavin'*, and is now in London's West End, where her larger-than-life likeness adorns the theater where she stars in *Thriller Live*, a hit Michael Jackson tribute. "I see the posters," she says, "and think, 'Wow! That's really me!'"

KIMBERLY CALDWELL

Season 2's Rocker Chick finally released her first album, *Without Regret*, in 2011. "It took me like, 75 years to get it out there!" she laughs. In part because she began landing a string of TV gigs—cohosting *Idol Chat* and *Idol Tonight* on the TV Guide Network, P. Diddy's *Starmaker* and VHI's *Rock'N'Roll Fantasy Camp*—as soon as she left *Idol*. Up next: a tattoo competition (she has "six or seven" tats herself) *Best Ink*, late March on the Oxygen Network. She's still pals with many from her *Idol* class ("Ruben, Blake Lewis; Justin is one of my closest friends") and even briefly dated Season 7 winner David Cook. But that's history: "I've got a special someone in my life," she says. "He's a professional soccer player. When things settle down a bit more with our careers, perhaps it will be time to take the next step!"

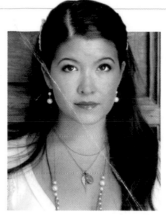

VANESSA OLIVAREZ
"I learned so much in a short time," says Olivarez, 30, who bounces between Nashville and Atlanta and performs in an alt-country duo, Granville Automatic. "I wouldn't change anything."

In 2003

CHARLES GRIGSBY
Eliminated after singing the unfortunately titled "You Can't Win," the Ohio native waited tables and painted houses between gigs. Most recent: performing at a Hard Rock Cafe in Thailand.

RICKEY SMITH
He's helping manage an Oklahoma City restaurant and "still singing!"; did a recent show in Cabo with *Idol* and *DWTS* alumni.

JULIA DEMATO
A full-time hairdresser, and sometime singer, in Connecticut, she says "Life is great. I have no complaints."

CARMEN RASMUSEN
Married to banker Brad Herbert, the son of Utah's governor, and a happy stay-at-home mom to Boston, 3, and Beckham, 1. "I look back at *Idol* with nothing but happy memories and a grateful heart," she says.

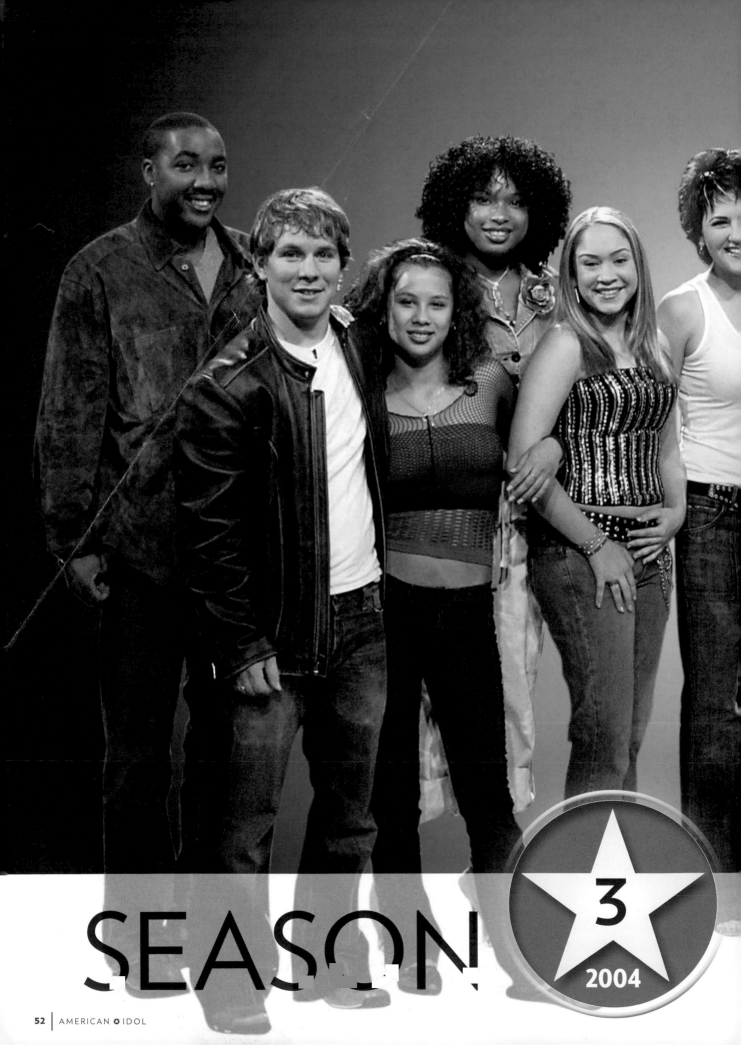

SEASON

3
2004

A diva-heavy lineup (8 of the final 12 were women) brought forth two great voices: Fantasia (Simon called her "the best contestant we've ever had"; see page 16) and eventual Oscar winner Jennifer Hudson (page 12). But a couple of teenagers— Diana DeGarmo and Jasmine Trias—gave them a run for the money

DeGarmo and her guy, Season 5's Ace Young, out and about and (below) performing together for charity last year in L.A.

DIANA DeGARMO

Season 3's runner-up has been all over the stage: in *Hair* and *Hairspray* on Broadway; a *9 to 5* road show; and *The Toxic Avenger* off-Broadway. She has wrapped a movie, *The First Ride of Wyatt Earp*, with Val Kilmer ("I got to ride horses, kiss hunky boys and die") and can currently be seen on *The Young and the Restless*. "I'm playing a Mob boss's gum-smacking, Snooki-wannabe daughter, and she's a blast," says DeGarmo, 24. "She's an aspiring singer. The show started off with her being tone-deaf, but now she's on the upswing. The writers have been good to me; I'm happy to go to work." Oh, and one other thing: DeGarmo and Season 5's Ace Young (see page 71) are a Big-Time Item, going on two years. "We became best friends doing *Hair*, ironically not through *Idol*. And, yeah, it just blossomed into a beautiful relationship."

MATTHEW ROGERS

The former University of Washington football player put some of his gridiron savvy to work when, finding the ready path to a music career blocked when his 11th-place finish precluded his joining the 2004 *Idol* tour, he made an end run. "When I got voted off, it was really hard for me," says the married father of two young sons. "It was tough watching all my friends travel the world and sing." But Rogers had another dream and he happened to know a guy who could help. "I called up Ryan [Seacrest] and said, 'Ryan, I want to do what you do.'" The *Idol* dream maker helped Rogers get his foot in the door. "I love it," says the host of Lifetime's popular *Coming Home* reality series, which focuses on the families of military servicemen and women and has taken him around the country. "I have been overwhelmed with the response [to the show]. It's a complete blessing."

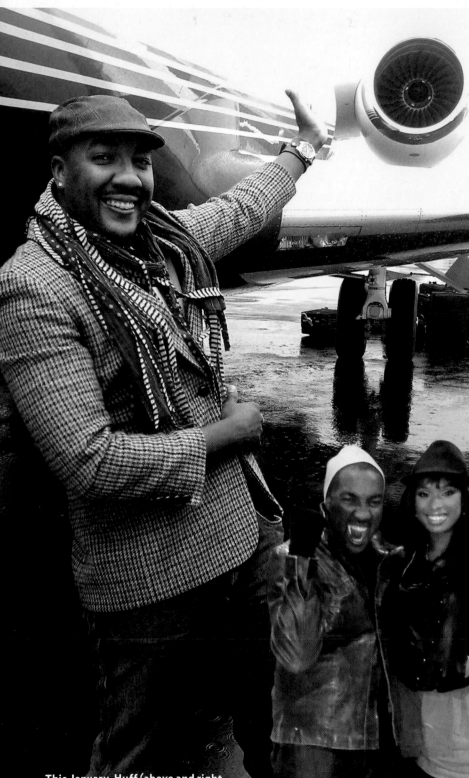

This January, Huff (above and right, touring with Jennifer Hudson and meeting President Obama) shot a video for a new single, "So Amazing."

GEORGE HUFF

Instead of bemoaning his fifth-place loss in the season of the dueling divas, the New Orleans native counted his blessings with his gospel-flavored debut album, 2005's *Miracles*. A year later when real disaster struck—Hurricane Katrina devastated his birthplace and destroyed his home, forcing his family to relocate to Dallas—he did not curse his fate. "I don't consider us victims," he says. "We are survivors. Being able to help [in the relief efforts], serve food and clean up—it felt good." After his single "Brighter Day" appeared in a Tyler Perry movie, he found just that: Last spring he hit the road with his *Idol* comrade Hudson as her backup singer and vocal arranger. "It was just like old times, singing together and [feeling] the family bond we've always had," he says of the tour—and a stop in Chicago last August to sing "Happy Birthday" to the President. "Life has been amazing."

JOHN STEVENS

Then a 16-year-old with a penchant for Rat Pack tunes—earning him the nickname Teen Martin—Stevens graduated *cum laude* from Berklee College of Music in 2009 and has been singing with the Beantown Swing Orchestra for four years. "We do classics from the swing era," says Stevens, 24. "I love it! It's wonderful performing in front of this 18-piece band!"

JASMINE TRIAS

The Hawaii-born singer—who often performed with a flower in her hair—has had great success in Asia, especially in the Philippines, where she landed endorsement deals, including as the face of the McDonald's "I'm lovin' it" campaign (they even named a meal after her, the Jasmine Trio, which she found "surreal but cool"). Closer to home, Trias, 25, headlines regularly in Las Vegas and is dating British entertainer Ben Stone.

LATOYA LONDON
The Battle of the Divas *Idol* vet sang in a duo, Urban Punk, and signed on to a four-month run with the L.A. production of *The Color Purple*.

AMY ADAMS
A vocal-chord injury and surgery temporarily idled her career, but she has been performing in *La Rêve—The Dream* in Las Vegas.

JON PETER LEWIS
Released two albums and produces an irreverent *Idol* commentary web show, *American Nobody*; developing a folk-rock opera.

CAMILE VELASCO
Big ups (signed by Motown; buying Dad a house) and downs ("working at Subway to pay bills" last year). About to work with the Fugees' Pras.

LEAH LABELLE
The Seattle high schooler didn't pass her *Idol* finals but she's since graduated from Boston's Berklee School of Music and signed with Epic Records.

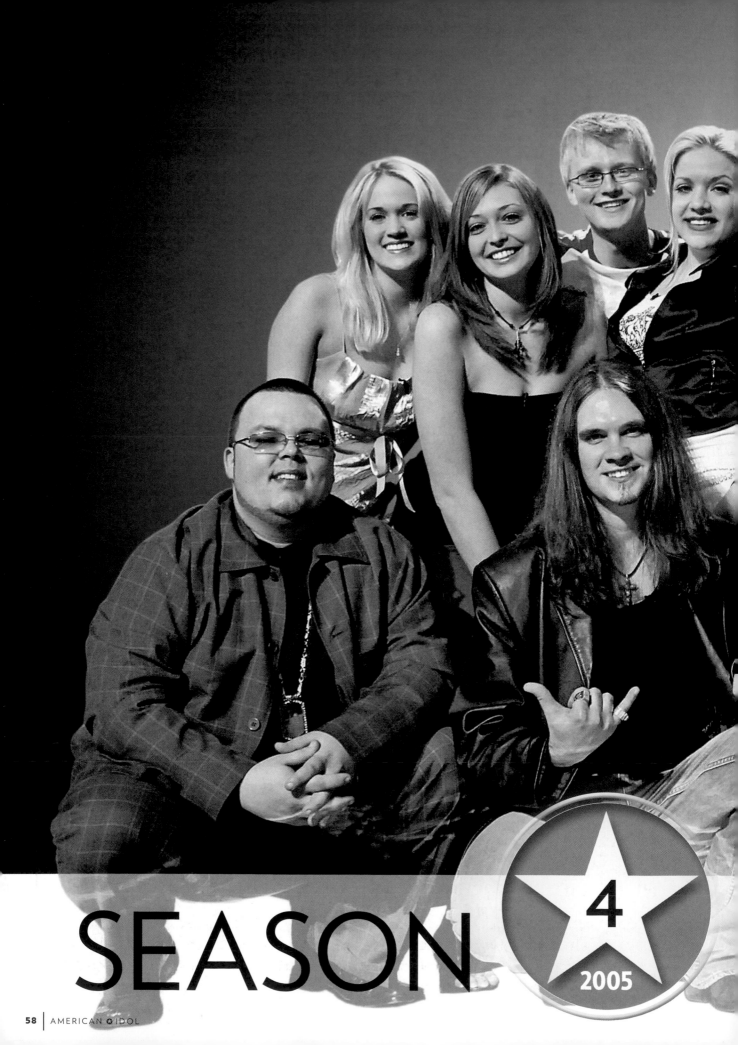

SEASON

★ 4

2005

Simon got the chance—and, of course, took it—to say "I told you so" when Oklahoman Carrie Underwood (see page 6), who had never been on an airplane before flying to L.A. for *Idol*, walked off a winner. But Season 4 also introduced the world to a couple of musical longhairs, a shy teacher with a great smile, and more

SEASON ★ 4
2005

ANTHONY FEDOROV

A penchant for dreamy ballads made him a youth-vote favorite. He seems to have spent the past few years working out—thanks, in large part, to being cast in *six* different productions of *Joseph and the Amazing Technicolor Dreamcoat*. "I really hit the gym and transformed my body to where I felt comfortable bare onstage," says Fedorov. "I'm so grateful to this show for getting me to take care of myself. Now I eat healthy and train six days a week." Fab abs have brought him modeling gigs; he also recently finished an EP, *Never Over*, and this summer he'll play the lead in Seattle's 5th Avenue Theatre production of *Rent*, "the role of a lifetime for me." On a more personal note, Fedorov, 26, whose brother Denis died of cancer in 2006, has been a spokesman for the Sarcoma Foundation of America. "What makes these cancers so deadly is that they are very often misdiagnosed, so it's really important for people to be aware."

Fedorov then (below, on *Idol* and with a donation to the Sarcoma Foundation in 2007) and now (right).

NIKKO SMITH
An R&B specialist—and the son of baseball Hall of Fame shortstop Ozzie Smith—the 29-year-old singer got to perform the national anthem at the 2006 World Series. He sings often in the St. Louis area and just released an album, *Speakaz Blow Radio*, and a new single of the same name.

JESSICA SIERRA
Two years after Simon was seduced by her smoky vocals, she auditioned for a reality show of a different stripe—*Celebrity Rehab with Dr. Drew*—by getting busted for cocaine possession. Now clean and the proud mom of son Kayden Cash, 2, (pictured in L.A. in 2010), she performs frequently and offers testimonials in the hope that her "life lessons," she wrote on her website, will deter others from "fast living and drug abuse."

SEASON 4
2005

BO BICE

Yo, Bo, where'd it *go*?!?!? The country rocker, who memorably sang "Sweet Home Alabama" with his idols, Lynyrd Skynyrd, on *Idol,* has trimmed his trademark locks, and also cut something else out of his life: "Ninety days' worth of [sobriety] has been great," says Bice, 36. "I've been able to see things through a different set of goggles—not just beer goggles." The Nashville-based rocker released his third album, *3,* in 2010 and is working on a fourth—whose arrival might coincide with his fourth child, due in April. This time, says the father of three boys, "It's a girl! I can't believe it. My wife, Caroline, was in desperate need of some estrogen around the house!"

Buzzcut bound? Bice (facing page, inset, in 2005; and, near left, with wife Caroline, and, clockwise from right, sons Aiden, Caleb and Ean) has dialed back the Lynyrd Skynyrd look over the years. Above: Bo on the go, racing cars.

LINDSEY CARDINALE

The Louisiana-born singer studied songwriting at Belmont University and now lives in Nashville, where she works in marketing. She hopes to have a country album out this year.

VONZELL SOLOMON

Recently in China, she has been on the road relentlessly. "She is happy and living her dream," says her father, Larry Goethe. "I couldn't be more proud."

MIKALAH GORDON

Lots of fans loved her, but being judged and ridiculed took a toll on the then 16-year-old: "I was heartbroken. I was devastated," she says. "I couldn't sing for three years." Which is why, seven years later, she is only now in the process of recording her first EP. ("It's the bomb, girl!" she swears.) The voluble Gordon has landed endless hosting and TV gigs (*The Unit*; *Living with Fran*) and is "happily in a relationship with a guy named Johnny. He's really supportive and takes me for my crazy ways. We have an apartment, a fish named Frank and a dog named Buckley. We're living the dream!"

NADIA TURNER

While on a USO tour in Afghanistan with Gina Glocksen and Justin Guarini, Turner stepped outside for a breath of air. Sitting on a picnic table was staff sergeant Kyle Petko. "I just fell in love," she says. "It was clearly meant to be. And the next thing you know, he was my husband!" Turner is acting in small, independent movies—most recently, *Poses*—and, in response to frequent fan questions about her ever-changing hair, has "started a blog to talk about it!"

ANWAR ROBINSON

Seven years on, the once-shy middle school teacher has shed his dreads and, to a degree, his dread: "The confidence was definitely something I had to work on." His album *Everything* came out in 2011. Making it, he says, "was a dream come true

SCOTT SAVOL

There were some bumps. Projects that withered; industry relationships that soured; in 2009, Savol's three-year marriage ended, so he pulled up stakes in Nashville and moved back home to Cleveland. Still, he says, "I've got people from around the world who send me messages on Facebook, fan letters, e-mail—people who are literally still waiting all these years for me to put something out!"

The wait is over: Savol, 36, just released his first album, *In Spite of All.* "I'm very happy with it," he says. "A lot of people say, 'Dude, you don't sound excited,' and it's like, 'You don't understand the ups and downs I went through.' So for me, once I see it on iTunes and Amazon, that'll be good."

Meanwhile he works for a plumbing supply manufacturer by day ("Bills gotta be paid!"), takes music gigs on weekends, hangs with his son, Brandon, 11— and has lost 60 lbs. All those people who used to winkingly call him Scotty the Body? Says Savol: "I'm going to keep them honest."

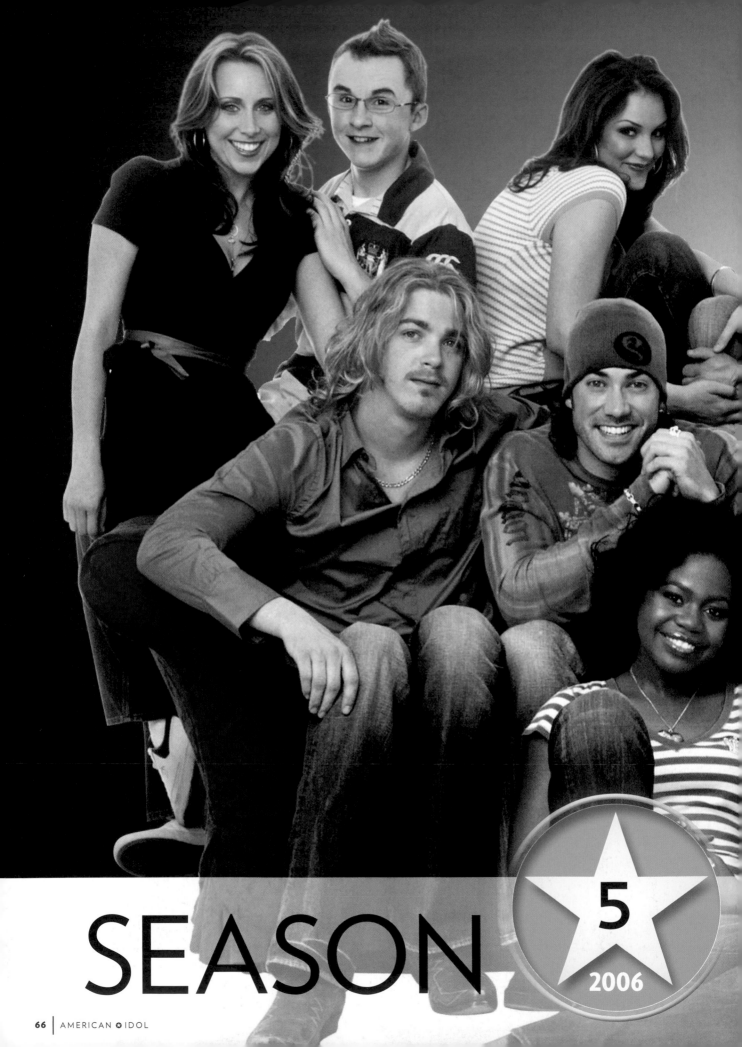

SEASON

★ 5

2006

Along with gray-maned winner Taylor Hicks, whose Soul Patrol fans voted him to victory, Season 5 produced more big stars—Kellie Pickler (see page 18); Chris Daughtry (page 14) and Katharine McPhee (page 25)—than any other season. And Pickler learned—on live TV!—that that's a *silent* "L" in "salmon"

TALYOR HICKS

By the time he won Idol's Season 5, the Gray-Haired Wonder had been rocking road houses and honky-tonks for a decade. So how'd he celebrate his win? With more of the same, virtually nonstop. Six years later, Hicks, 35, is finally putting down roots, in Nashville. "I am so happy to be one place now," the Birmingham, Ala., native says of his adopted home. "Being from Alabama and having country roots and being a roadhouse musician, [Nashville] is a really great place for

me." Hicks's presence remains strong in Birmingham, where his Ore Drink & Dine restaurant—formerly the Open Door Café, where fans gathered to cheer him on during his march to the *Idol* title—is a popular spot for locals and *Idol* tourists alike. But Nashville's stature as the country music capital was a powerful lure for Hicks. "It's got so many influences and so many different artists live here, it's a natural fit," he says. But Nashville's rich cultural life isn't all that holds him. "It's nice to have a place where I can go to Bojangles and to Kmart and Wal-Mart. I'm hittin' all the marts!"

ELLIOTT YAMIN

He's been rockin'—like you wouldn't believe! "I ran down eight flights of stairs in my hotel while it was rocking 8.8 style!" Yamin, 33, says of the 2010 earthquake that hit Chile hours after he sang at a music festival. He'd already shaken the charts when his 2007 single, "Wait for You," hit to No. 3, and he's just wrapped his third album, *Gather Round*. Traveling the world with Idol Gives Back, the show's charity campaign, Yamin always records his favorite program. "I'm an *Idol* junkie!" he says. "Always will be."

MANDISA

It was the diss heard 'round the world: "Do we have a bigger stage this year?" Simon Cowell quipped after the plus-size gospel singer finished a number. Fans took offense but Mandisa credits Cowell for spurring her on to greater success and better health. "I don't think I would've made it as far on the show if he hadn't [made] fun of my weight," she says, equally proud of her post-*Idol* Christian music career and her weight loss. With three Grammy nominations—and 100 less lbs.—under her belt, Mandisa has fond feelings for Cowell. Producers, she says, "were trying to up the drama—kind of egging me on to let him have it." Instead, she decided to "show him love and forgive him." Her response endeared her to viewers and, she says, to Cowell, with whom she stays in touch. "I was so excited to tell him I was nominated for a Grammy; he said 'I'm so proud; I knew you could do it!' That meant so much to me!"

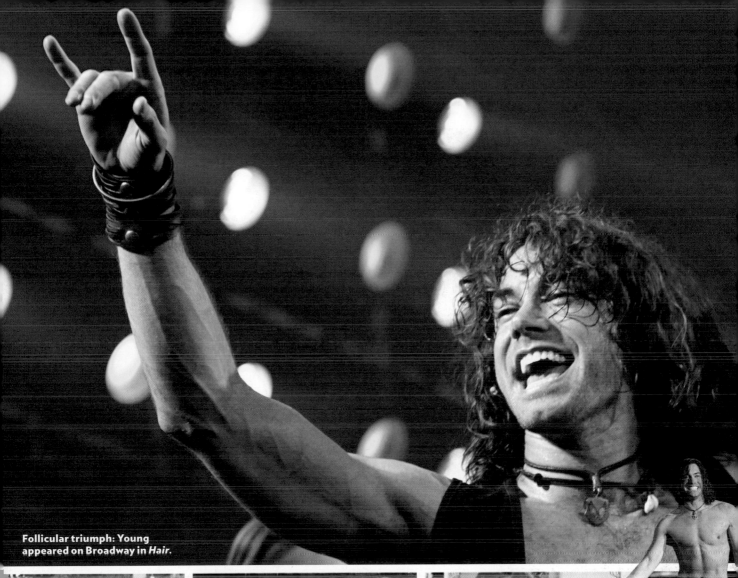

Follicular triumph: Young appeared on Broadway in *Hair*.

ACE YOUNG

For some people, it's the wink of an eye, the lilt in a voice. For Season 5's Ace Young and Season 3's Diana DeGarmo, "We knew we were attracted to each other the moment we got naked!" says Young, 31. The occasion was nude rehearsals for the Broadway production of *Hair!*, in which both won roles. "She said, 'You're not looking, right?'" he recalls. "And I was like, 'Oh, no, no, not at all!' But I was looking and I was *sold*!" In less personal, totally professional news: Young received a Grammy nomination for cowriting Daughtry's hit "It's Not Over" ("the fastest-selling rock song of all time," he notes) and wrote another song, "Let Go," that went No. 1 in Sweden. Still, it's talking about DeGarmo that really gets him going: A year after they began dating, she moved to L.A., where he now lives. "The moment she got here, she realized I wasn't gonna let her get an apartment and I wasn't gonna let her leave," he says. "It was up to her—either we're doing this or we're not. Thankfully she was all in!"

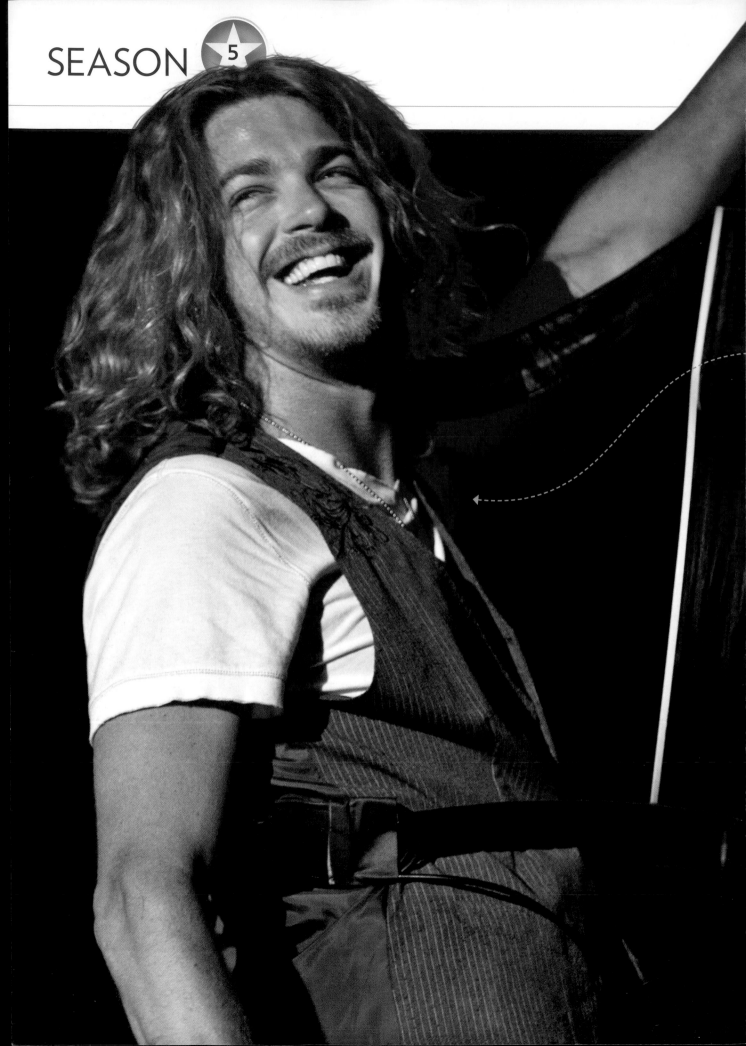

BUCKY COVINGTON

Down-home music and heart-twanging good looks made him a favorite. But when the North Carolina singer met the good ol' girl of his dreams—bartender-turned-fiancée Katherine Cook, who now doubles as his publicist—he was too shy to ask her out. "I had my sister-in-law ask for me," he says. "It was very 7th grade. But I don't like rejection. I came off *Idol*, so I'm good—I've had enough rejection!" Even now, long after his self-titled first album debuted at No. 1 on *Billboard's* Country Albums chart, he gets a queasy feeling when a new *Idol* season rolls around. "Once you've been in that wringer, you watch for five minutes and start getting that churning-in-your-stomach feeling again."

PARIS BENNETT

For the singer and actress (Tyler Perry's *Aunt Bam's Place*) known to fans as Princess P, soulful pipes are a family affair. Daughter Egypt, now 3, seems to have inherited the musical genes that helped her then 17-year-old mom to a 5th-place *Idol* finish. "She can tell you when she hears my grandma on the radio and when she hears my mom sing," Paris says of her Grammy-winning Sounds of Blackness forebears. Paris, who is working on a follow-up to her 2007 album, *Princess P*, says Egypt also harmonizes with Mom on her own tunes. A belter from birth ("Man, does she have lungs on her!" says Paris) Egypt will be eligible for her own *Idol* audition in 2023.

LISA TUCKER
Now an actress (*Vampire Diaries*; *The Game*), Tucker, 22, credits *Idol* with helpful prep: "To learn a song in a couple of days and perform it in front of millions of people—*that's* pressure!"

KEVIN COVAIS
The 16-year-old dubbed Chicken Little got chopped, but his sky didn't fall, thanks to one viewer: a director who launched the *State of Georgia* (ABC Family) star onto a post-*Idol* acting career.

MELISSA MCGHEE
Bounced after forgetting the lyric "this time could mean goodbye," she has appeared as a mermaid, had polyp surgery and cohosted *Suds & Cinema*, a movie series on Tampa TV.

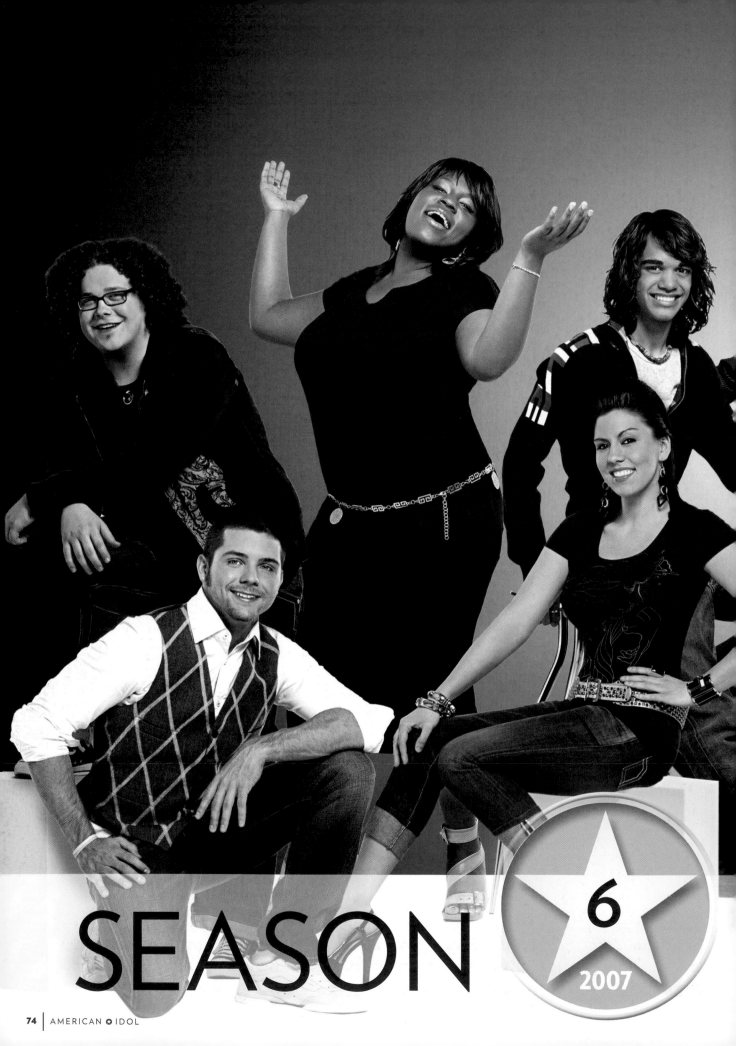

SEASON

★ 6

2007

Preternaturally poised 17-year-old Jordin Sparks won; beat-box boy Blake Lewis broke boundaries; Melinda Doolittle did a lot that impressed fans; and punksters Green Day (!) appeared on the season finale. But for millions of Americans, the magic that was Season 6 can be best captured with only one word: Sanjaya!

JORDIN SPARKS

Idol's youngest titlist—she was 17—saw her first album go platinum, landed on Broadway in *In the Heights* and has finished filming the remake of *Sparkle,* co-starring the late Whitney Houston. She has nothin' but love for her *Idol* experience: "It was so fun because I was such a big fan of the show—being on it was like the ultimate fan experience." Post-*Idol,* she dropped from a size 14 to a size 8 and rocked a bikini in PEOPLE's June 27, 2011 issue. "Hollywood large is so different than real-life large," says Sparks, who said the change happened gradually, mostly through portion control. "It was just a choice. It wasn't like I didn't like who I was." But it was a choice *Idol* helped her make: Being on the show every week standing next to Ryan [Seacrest], "I looked massive. I love Ryan, but he is a tiny little thing!"

Jordin (above right) has a role in the upcoming *Sparkle,* and her own fragrance, "Because of You."

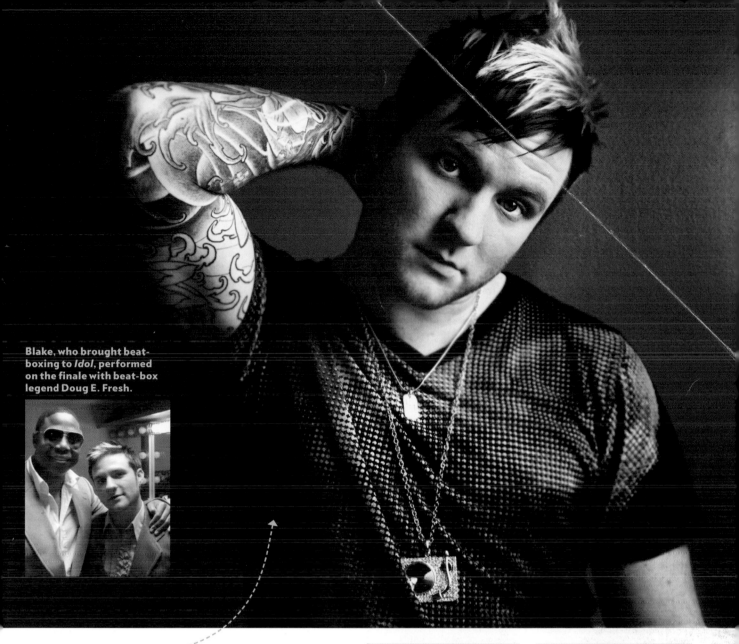

Blake, who brought beat-boxing to *Idol*, performed on the finale with beat-box legend Doug E. Fresh.

BLAKE LEWIS

With two-tone hair, homemade threads and street-beat musical style, he made the *Idol* stage safe for club kids and one notable trendsetter in his own right: Adam Lambert. "He was a big fan," says Lewis, now a Los Angeles-based deejay and dance-charts shaman. "He said, 'You're one of the reasons I was excited to be on the show.'" Lewis, whose surprise remix versions of classic tunes helped thrust him to a second-place finish, says he didn't set out to break the *Idol* mold: "I was just being me." Even so, he was happy to mentor younger performers, advising Lambert and others to "just be yourself and if you're scared, find the right people to talk to and find your lane." Translation: When producers challenge contestants to swerve from their sweet spot, merge styles. "[Don't think] 'I'm not into country,'" he advises. "Do country but in your lane—find the right song and arrange it differently." That method works in his personal life too, says Lewis, a serial dater who just might settle down. "I finally met someone," he says, "and I'm kinda into it!"

LAKISHA JONES
Jones, 32, appeared on Broadway in *The Color Purple* and released an album, *So Glad I'm Me*. She married financial adviser Larry Davis in 2008.

CHRIS RICHARDSON
An Air Force brat and former Hooters supervisor, he overcame "Justin Timberfake" quips, succeeding as a songwriter and collaborator with Idols Blake Lewis and Jordin Sparks. He signed with hip-hop's Cash Money label.

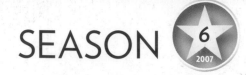

SANJAYA MALAKAR

Idol fame got Sanjaya enough online votes to be named one of TIME's 100 Most Influential People of 2007 and Best Male Reality Star at the Teen Choice Awards. That led to more reality TV, an autobiography (*Dancing to the Music in My Head*) and a part in an off-Broadway show, *Freckleface Strawberry*. He's working on an album and helping his mom, who was hit by a car last September. "She was in a coma for almost two weeks," says Sanjaya, 22, but is now "doing well. She luckily doesn't have any major injuries."

THE MANY STYLES OF SANJAYA

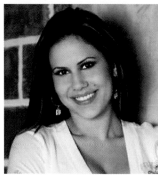

PHIL STACEY
The country-music-loving son of a preacher's son is busy doing what comes natural. "I turned my whole career into a ministry," he says. "I travel the world [performing] at different events that are mixing God and country."

HALEY SCARNATO
Currently living in Las Vegas, where she performs at corporate events, and has sung the national anthem at NBA games and sings with a country trio, Fairchild. She recently recorded a single, "How I Feel," and is working on an album.

GINA GLOCKSEN
"There's awesomeness everywhere!" That's the Chicago-area rock chick's take on her best-of-all-world's life. "I have a band and [her science teacher husband] Joe's my bass player. It's called the Gina Glocksen Band—very original!"

CHRIS SLIGH
Leaving sexy's return to Timberlake, his *Idol* mission was "bringing chubby back," he vowed. "Let's be honest," says Sligh, now a pastor, Christian music star and co-author of the Rascal Flatts hit "Here Comes Goodbye." "I don't look like a rock star."

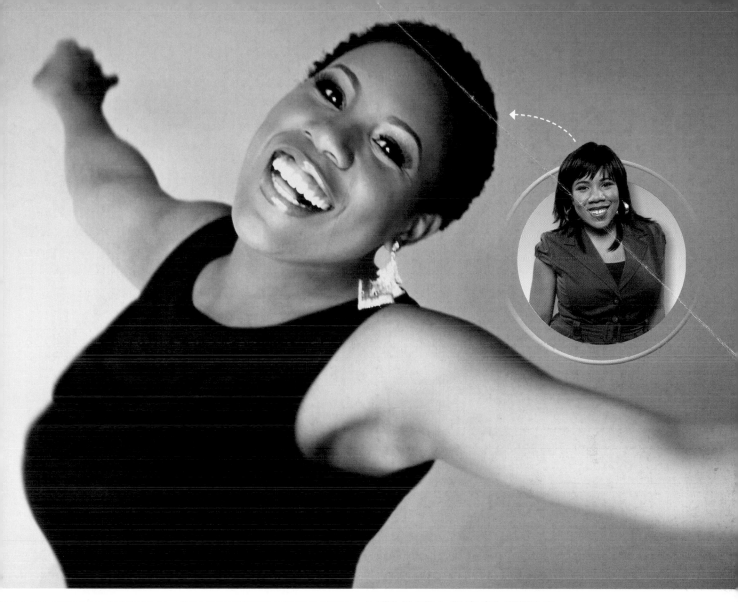

MELINDA DOOLITTLE

She earned her own share of adoration: Enough fans speed-dialed their votes to carry Doolittle to a third-place finish. But *Idol* worship had a whole other meaning for the gospel thrush from Brentwood, Tenn. Already a seasoned professional—she sang backup for the illustrious likes of Aaron Neville, CeCe Winans and Michael McDonald before her first *AI* audition— Doolittle bows down before her own all-time idol: the Queen of Soul. In 2008, she says, "I got to play with the Muscle Shoals Rhythm Section at the Musician's Hall of Fame ceremony. They're the folks who played on a lot of Aretha Franklin's records. Fast-forward to last October and I got called to pay tribute to Aretha at the Kennedy Center," Doolittle continues. "And there she was! Aretha Franklin was sitting in the audience as I sang 'Wonderful' and 'Since You've Been Gone,' and I'm on the bill with Chaka Khan, Lauryn Hill, Sissy Houston and I'm like, '*What is going on* right now?'"

STEPHANIE EDWARDS
The soul singer has released at least three singles—including "On Our Way," which benefited the Leukemia and Lymphoma Society—and, according to the *Savannah Morning News*, was a junior at Savannah State last year.

BRANDON ROGERS
A backup singer for Christina Aguilera before *Idol,* Rogers released *Automatic* in 2006, appeared on FOX's *Bones* in 2008 and is now working with a new band, So & So. As for cutting his Afro: "My shower drain thanks me," he says.

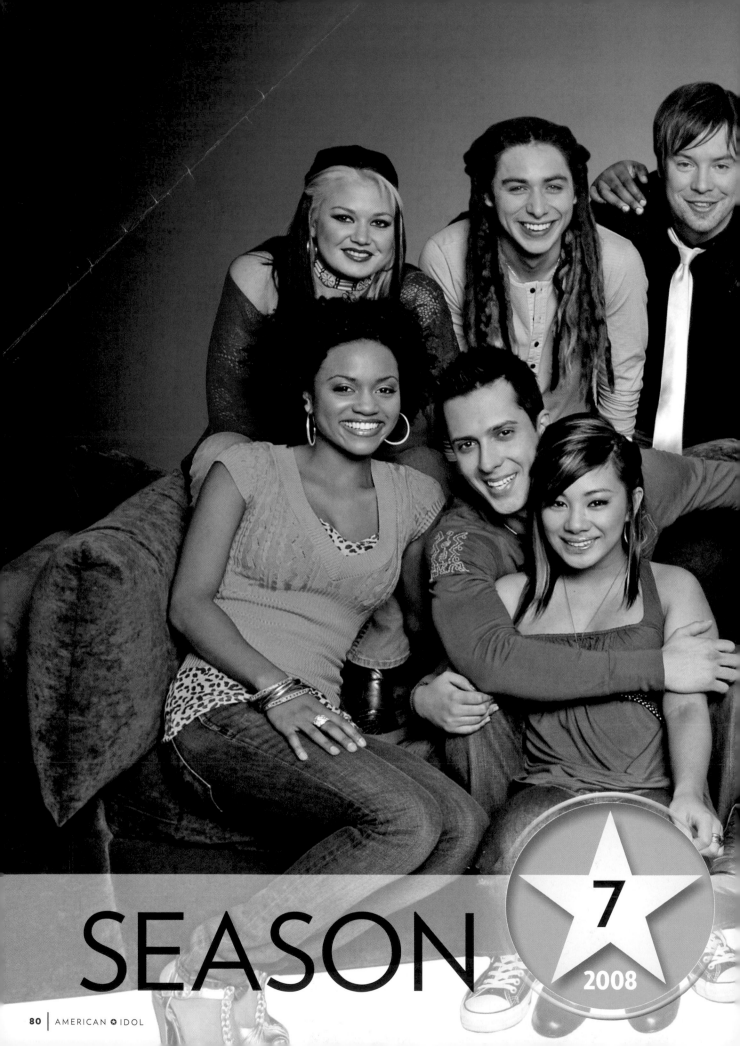

SEASON

7

2008

Had it been David vs. Goliath, no one would have cared. But David Cook (a 28-year-old Missouri rocker) vs. David Archuleta (a 17-year-old teenthrob who got the sighing tween vote) was an even and epic battle that lasted all season. Spoiler alert: Cook and Archuleta sang their hearts out, but the winner was. . . David!

DAVID ARCHULETA

Idol's 2008 teen flame actually scored three Billboard Hot 100 hits from his show performances—a feat that helped get him a deal with Jive Records when the season ended. His self-named first album brought him a No. 2 single, "Crush," and he played to his audience by appearing on *Hannah Montana* and *iCarly* and opening for Demi Lovato. Archuleta split from Jive last year and is now filming a miniseries, *Nandito Ako* (*I Am Here*), in the Philippines, where he has a large fan base, before he goes on a two-year mission for the Mormon Church, a requirement of his faith. Why TV? "Before, I never had the guts to do something like this, but the people are easy to work with, and it was a project that worked within the time frame before I leave on my mission," says Archuleta, 21. "It seems like something that would be very special to leave my fans before I left." He doesn't know where his mission will take him, only that, for him, "it's one of those things that you just feel you have to do and know that there is something in that experience that you need."

THE **YEAR OF** THE
DAVIDs

DAVID HERNANDEZ

Since *Idol*, Hernandez, who grew up poor and helped pay for college by selling knives door to door, has toured in numerous *Idol* shows and in productions called *Ballroom with a Twist* (with Season 6's Gina Glocksen) and *Motown Memories*. "I have been touring since I got off the show, which is a blessing," says Hernandez, 28. Highlights? "I opened for John Legend, Obama's Inauguration in D.C., which was hosted by Jessica Alba and Maroon 5—just a lot of cool stuff."

DAVID COOK

Season 7's winner has one platinum album, *David Cook*, under his belt and is already writing songs for his third collection. For a guy who was working as a bartender, post-*Idol* life has been a head-spinning experience. "The show just went by so fast, and now I think, dang, that was four years ago," says Cook, 29. "I remember we'd get royalty checks for being on the show, and I was able to send a check to my roommate for six months' back rent—I was paying $200 a month in Tulsa and couldn't afford it." Now, to be in a position where he can "prepare for the future, where I'm not hand-to-mouth—I'm blessed." Cook would also like to thank his guitar: "I'll contend til the day I die that I was not the best singer that season. So I leaned on my musicianship a little bit more, and that's where I found my niche." And all that David vs. David hype? "All [David Archuleta and I] could do was laugh it off," says Cook. "I get it—*Idol*'s a TV show. But we were like, 'What on earth is going on?' Archie and I get along great; all you can do is laugh at it."

BROOKE WHITE

She was known for singing "You're So Vain" directly to Simon Cowell and for never having seen an R-rated movie. So what's her biggest news since *Idol*? A baby girl, due at the end of May. "My husband always joked that he would be excited for the day we had kids but dread the day I became pregnant!" says White, 28, who figured she'd have "every symptom in the book. But my baby's been a little gem to me already, and I really haven't slowed down since finding out the news." She and husband Dave Ray, an accountant, have been together eight years and were delightfully surprised. "We always wanted to have a family but we never anticipated it taking this long," she says. "It was quite a surprise, but a happy one."

White released an album, *Songs from the Attic*, in 2005 and another, *High Hopes & Heartbreak,* in 2009. She launched her own label, June Baby Records, with Randy Jackson and teamed with him again for a FOX TV movie, *Change of Plans* (she made her acting debut; he produced the soundtrack). She currently performs in a duo, Jack and White, with songwriter Jack Matranga.

White keeps in touch with many of her *Idol* castmates, including Carly Smithson, Jason Castro, and David Archuleta. Last time she changed residences, she says, "David literally called and said, 'Hey, can I help you move?' "

CHIKEZIE EZE

The former TSA screener at LAX was arrested for identity theft in 2010 (he pleaded no contest and was given three years' probation), married in 2011 and is now in a Michael Jackson tribute show in Germany. "I look back on my *Idol* experience fondly-ish," says Eze, 26. "The ride was wild; if there's anything I learned, it's to be true to yourself." Season 6's Brandon Rogers played at his wedding. "I was blessed by his presence," says Eze. "If you read this, B, you are the SICKEST!"

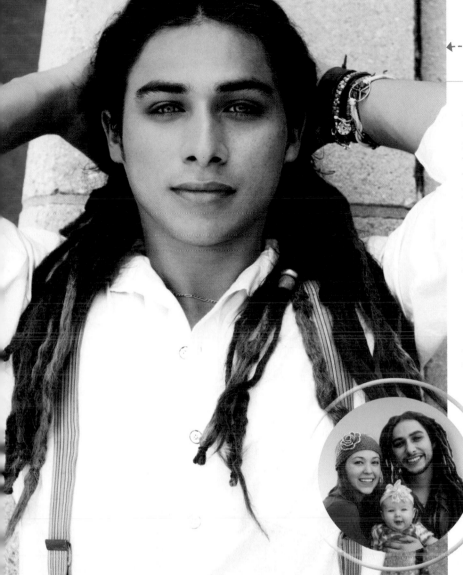

JASON CASTRO

The seaon's No. 4 finisher, who memorably sang "Over the Rainbow" while accompanying himself on ukulele, which he learned in a week, has been busy personally and professionally: In January 2010 he married Mandy Mayhall, whom he'd known since high school; last August they welcomed a daughter, Madeline Emilia Castro. "It's unreal how much joy this little baby brings into our lives," he says. "It really is a miracle to me." Professionally, he was signed by Atlantic Records and released two albums, *Jason Castro* and *Who I Am*. His next album will be for the Christian music label Word, which is affiliated with Atlantic. "It happened in a very natural way," says Castro, 25. "Christian retail stores were interested in stocking my CD mainly from a video thing I'd done with this group I Am Second. My faith has always been out there, but it's been really cool to connect with an entire new audience, especially getting to sing songs about my faith." Whatever the genre, though, he vows to continue rocking dreads: "For sure! It's one less thing to worry about—the hair's always there, lookin' good!"

SYESHA MERCADO

After *Idol* she toured the U.S. and Japan for a year in *Dreamgirls*. "*Idol* was like bootcamp—a whirlwind," she says. "Then *Dreamgirls* was a whole different level, 8 or 9 shows a week, dancing in high heels. It definitely made me a more confident performer." She is currently working on an album.

MICHAEL JOHNS

Season 7's heartthrob released an album, *Hold Back My Heart,* in 2009, but might have had even more fun working on the soundtrack for *Don't Look Down,* a documentary about snowboard god Shaun White. "Watching him do his runs, and saying, 'We want it to sound something like this,' that was really, really fun," says Johns. "And it sold well, so I can't complain. It's awesome."

CARLY SMITHSON

Four years after her *Idol* exit, the Irish-born singer is hanging with The King: She performs in the Las Vegas Cirque du Soleil show *Viva Elvis*. "It's been honestly just amazing," says Smithson, 28. "I've always been a big fan of Cirque du Soleil. I actually didn't believe the casting lady when she called and asked if I would be coming. I thought it was one of my friends playing a joke."

On her weekly break, she heads to L.A. to work with her band We Are the Fallen on their next album. She finds the contrast delightfully disconcerting: *Viva*, she says, "is very upbeat—everything that I'm not! It's like going from my band to *Glee*!"

Something else that's new and fun: getting to stay for the entire show. During her first big stage gig, in *Les Miserables*, she recalls, "I was 9 years old. I've never actually seen the second half! You are kind of shuffled in and out, because children can't be there that long." This year, she says, her husband, tattoo artist Todd Smithson, "has promised that I will see the second half of *Les Miz*!"

In 2008

RAMIELE MALUBAY

After working with people who wanted to put her in "big hoop earrings and hoochie shorts—I wasn't down for that!" she moved back to Miami to try new producers. She pays the bills with singing, *Idol* savings and an online crochet business, Bowties & Cutiepies.

AMANDA OVERMYER

On *Idol* you gotta be something, so she was the Rock'n'Roll Nurse Who Likes Motorcycles. Now? "I'm still in Indiana—still out in the sticks!" says Overmyer, 27. "I've been able to tour every year. Our big thing is bike rallies, because of the whole Harley thing. The winter, we're pretty slow, so I do private parties and acoustic stuff. I put out an album, *Solidify*, which did fairly well, and we're working on a second one now." Last December she married Cozy Johnson, her drummer: "We're pretty inseparable; he's my best friend." Her album will be called *Midwest Housewife*: "Big ups to the Midwest!"

KRISTY LEE COOK

The country star-wannabe said she'd sold her "best barrel horse" to raise money to get to the *Idol* auditions. Latest credit: starring in the reality series *Goin' Country*, in which she hunted both animals *and* a recording contract. Says her rep: "The series provided the classic American story of a girl, her guitar and her gun."

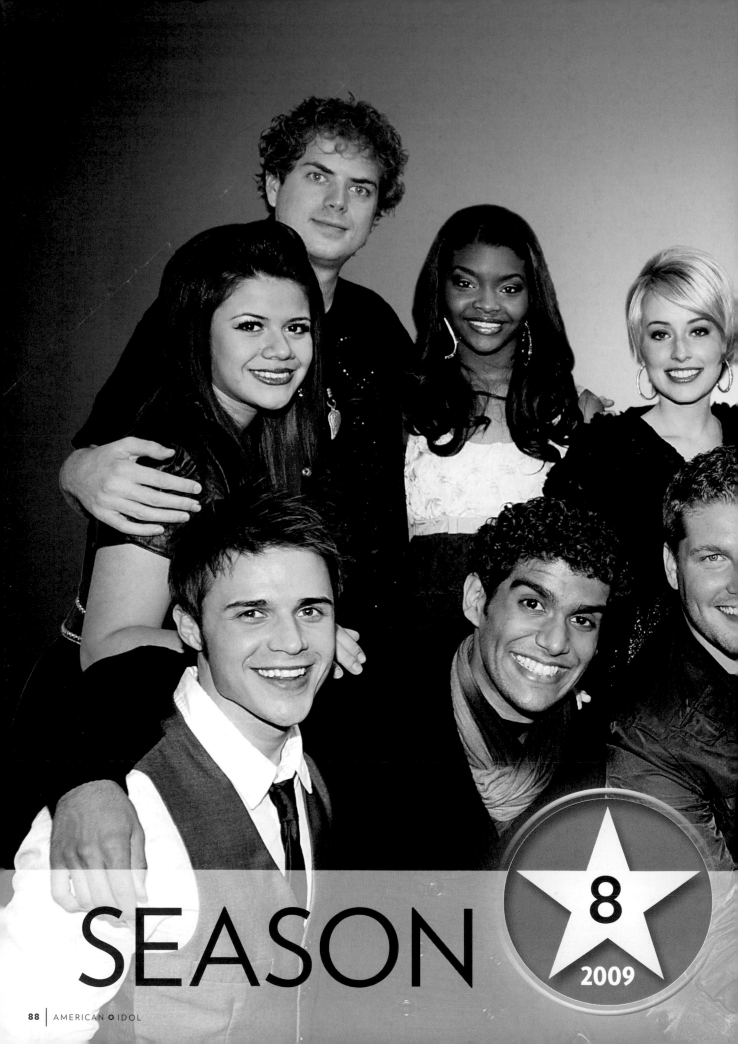

SEASON ★ **8**
2009

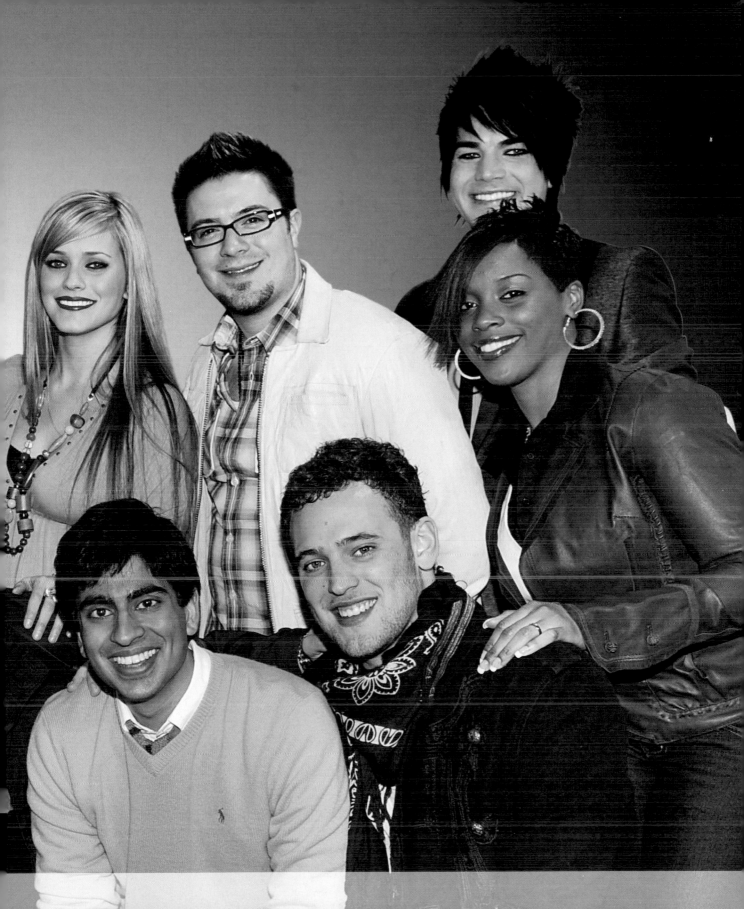

Acoustic guitar-strumming Kris Allen took the top prize, edging out flamboyant Adam Glambert—er, wait, that's Lambert! (see page 20)—who combined Bette Midler–like understatement with a touch of Freddie Mercury's reserve. Faced with a tough choice, America picked flannel over Spandex

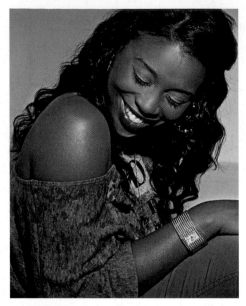

LIL ROUNDS

After losing her pad (to a tornado), car (stolen) and record label (folded), she has new wheels, a roof overhead and is happily at work on an indie album. "I am blessed," she says.

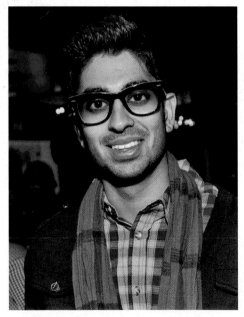

ANOOP DESAI

Dubbed Anoop Dogg by Randy Jackson, he lives in Atlanta, works on electronic and pop music and is in no hurry to follow pals down the aisle. "I'm happily single," he says. "I've been a groomsman in six weddings in a year and a half. I've had my fill!"

KRIS ALLEN

Season 8's winner had a successful self-named 2009 album and three Top 20 hits, "No Boundaries," "Heartless" and "Live Like We're Dying." After time on the road opening for Keith Urban and Maroon 5, the married *Idol* winner is often in the studio in L.A., while his wife, Katy, tends the home fires in Conway, Ark. "It's hard, but she's got a new job and she's enjoying that," says Allen, 26. Also, he says, the couple has a French bulldog, Zorro, "who's become our baby, so he keeps her company." His biggest *Idol* lesson? "Be confident. I feel like if you show confidence that you are good enough to be where you're at, people can see that." Of the success of runner-up Adam Lambert, he says, 'After the show, it was like, 'Well, is Adam going to do better than Kris? Is Kris going to do better than Adam?' I don't think either of us cared. He has his thing and I have my thing and I'm so happy for him. He's supertalented and such a good guy."

One favorite post-*Idol* highlight: "We went on tour with Keith Urban, and every night he would ask me to sing, and it was kind of funny because . . . he's Keith Urban!" says Allen. "He's one of the biggest stars in the world, he's married to Nicole Kidman, and I'm pretty sure they own Australia!"

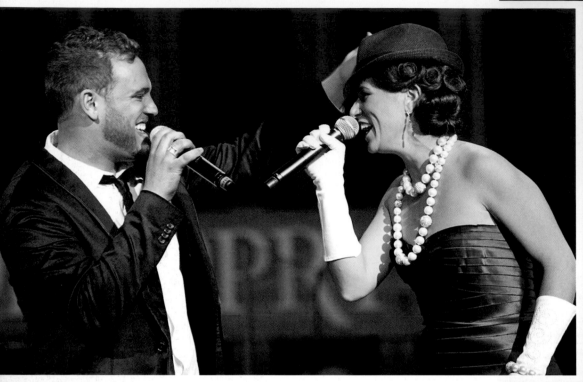

MATT GIRAUD

He needed the first-ever judge's save to make it to a fifth place *Idol* finish, but his bluesy style and fedora have suited him ever since. The Dearborn, Mich., native's 2010 "You Don't Know Me" duet with Anna Wilson (rocking Matt's signature chapeau) was the No. 1 download on the iTunes jazz chart.

JASMINE MURRAY

Sixteen during *Idol*, Murray is now a freshman at Mississippi State University, helps lead worship at her local church and is working on a demo for an album. Of *Idol*, she says, "I'm just thankful."

MICHAEL SARVER

For the oil rig worker, who released a successful 2010 debut CD, the show is "a blessing and a curse. I'm proud [of *Idol*], but it's hard [not to] feel you're only going to be known for that." He just put out a single, "I Like to Like You."

ALLISON IRAHETA

She wowed the judges and guest star Slash with her powerhouse take on tunes by Janis Joplin and Aretha Franklin. But the pros who praised her were equally flummoxed when the fiery-haired rocker flamed out with a fourth-place finish. Iraheta, tweeted rockers' mentor Slash, "didn't deserve to be voted off *AI* so soon; she has amazing potential." Fans thought so too, but Iraheta, who also sings in her parents' native Spanish, was dropped by her Jive Records label after her 2009 English-lyrics-only debut *Just Like You* sold poorly. Disappointed but undaunted, she told the *Sun Sentinel* she plans to "get back to singing in Spanish" and has said she harbors no regrets. Since *Idol*, she said, "people now know who I am and what I do. It's been an amazing experience."

SEASON 8
2009

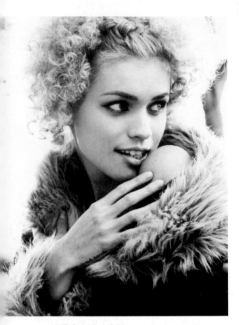

MEGAN JOY
The no-longer-single mom (she wed Quinn Allman, guitar player for the alt-rock band The Used, in August) gushes on her Tumblr blog about how family, friends and fans came together to finance her yet-to-be released debut CD. Wrote Joy, 26: "I am so full of gratitude and love I could burst!"

DANNY GOKEY

The source of his soulful passion was no mystery. Weeks before *Idol* began, Gokey suffered a staggering loss: His wife, Sophia, died following routine surgery for congenital heart disease. Drawing strength from his Christian faith and buoyed by his love of '60s soul, the former Milwaukee worship leader won over viewers with his affable charm and stylish flair for funky eyewear—and with emotion-packed performances.

In the years since, Gokey has overseen his Sophia's Heart children's charity, dedicated to the memory of his late wife. Along with post-*Idol* success—his *My Best Days* debut album sailed up the charts in 2010, and fans will soon be able to don specs from a line of designer glasses he is developing with Match Eyewear—Gokey also scored in the heart sweepstakes. "It was a win for me in my life," the teary-with-joy groom told PEOPLE following his January wedding to Peruvian beauty Leyicet Peralta. "There's hope again." While Gokey feels certain that he and his "soulmate" are meant for each other, he was shocked when she raised the hem of her bridal gown as he knelt to remove her garter. "She wore pink Crocs!" His diplomatic reaction: "Ugly . . . but comfortable."

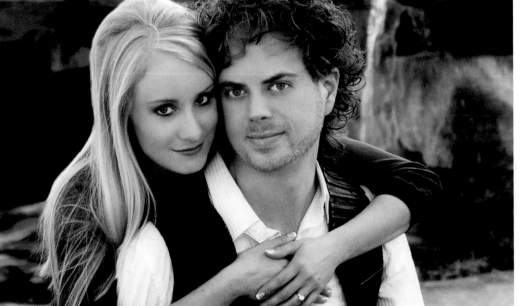

SCOTT MacINTYRE
As his stunning résumé proves, the former Fulbright Scholar, multi-instrumentalist (piano, drums, bass, guitar), singer (Top 12 *Idol* finalist), recording artist (*Heartstrings*), author (his autobiography is due in April) and newlywed (he tied the knot in August) isn't slowed by the severe tunnel vision that renders him nearly blind.

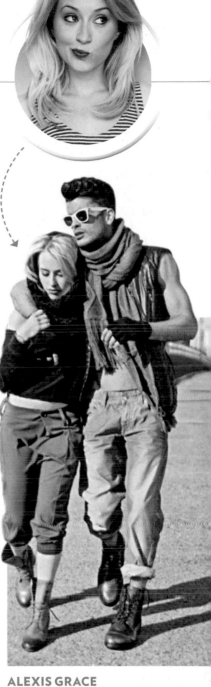

JORGE NÚÑEZ

After *Idol*, the Puerto Rican-born Núñez—who recently earned a comparative literature degree—rates singing in New York City's Puerto Rican Day Parade as "the best experience of my life. All I could see were blue, white and red, the colors of the Puerto Rican flag. I wanted to cry."

ALEXIS GRACE

The pink streaks are gone ("A girl has to change up her hair now and then!"), but Grace is flourishing, cohosting a Top 40 radio show in Memphis, *Maney and Alexis*; appearing in a local production of *Chicago*; and even doing some modeling ("I never thought I could—I'm like 5-ft. tall!"). Her dad—whom fans will remember needed a heart transplant—is "doing better" and still on the waiting list.

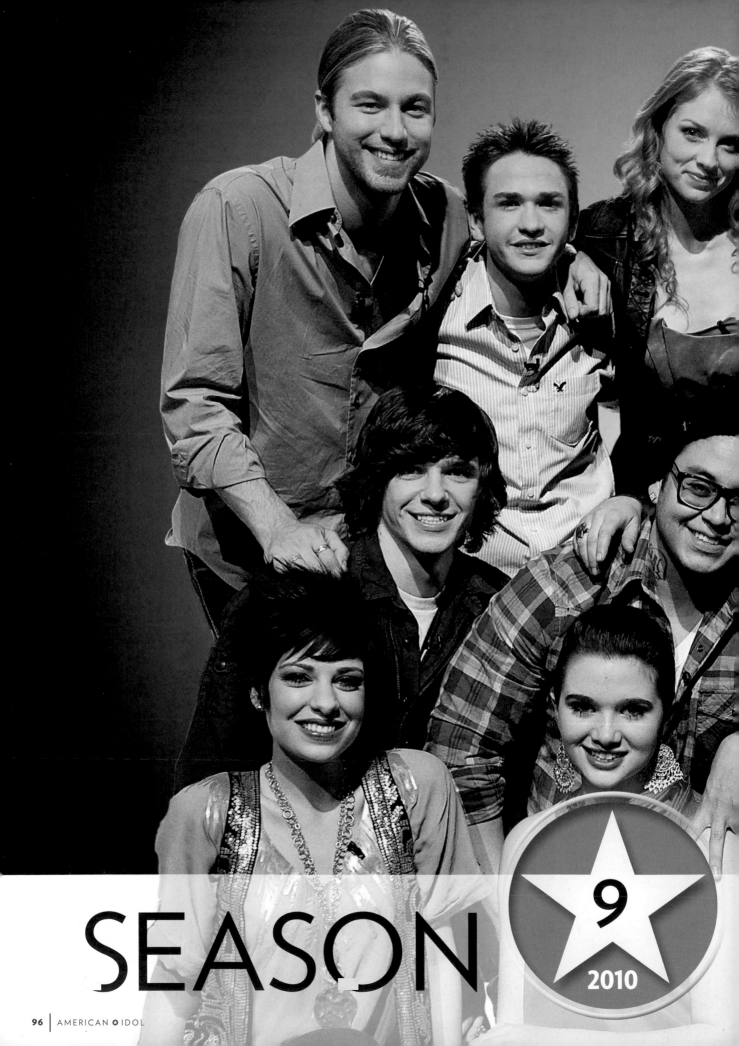

SEASON

9
2010

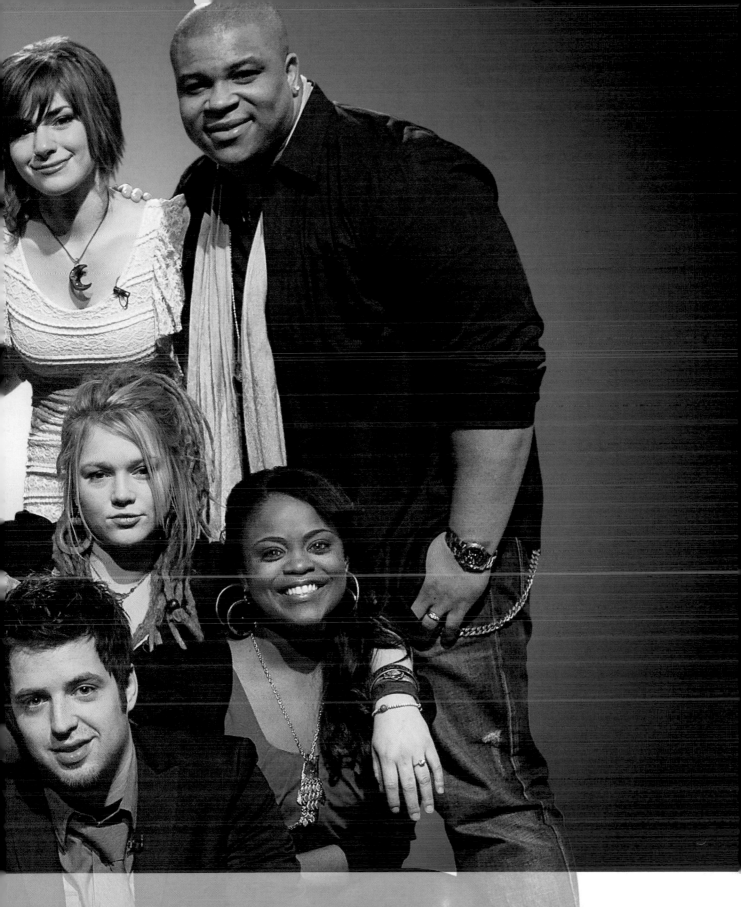

It was the Season of the Switch: Paula Abdul was gone, Ellen DeGeneres in, and Simon—a lame duck after announcing he'd exit at season's end—warbled his swan song. Onstage, guitars rang out, as did the voices of guest stars Lady Gaga and Justin Bieber; and millions of viewers, in the end, made a (Lee) DeWyze choice

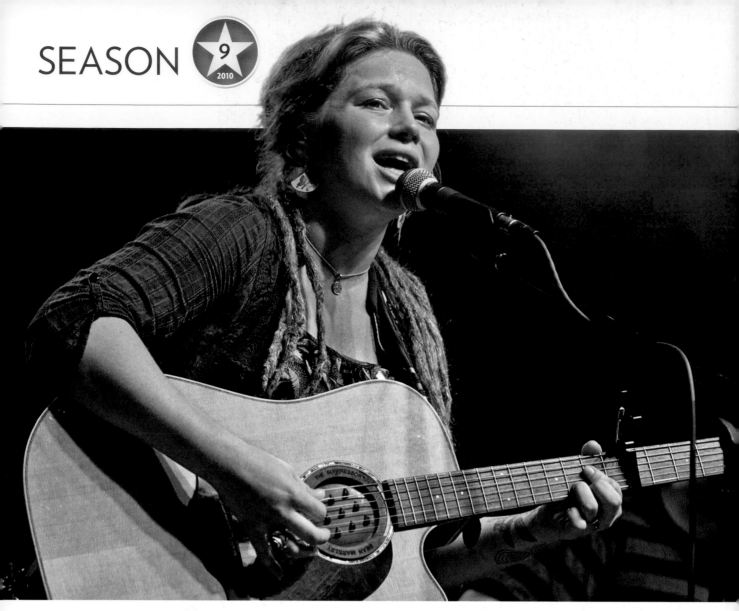

CRYSTAL BOWERSOX

The then-single mom from Elliston, Ohio, who was never in the bottom three, finished as Season 9's runner-up and quickly signed with Jive records. She had some success with her album, *Farmer's Daughter*, but then Jive went out of business and she had to regroup. Nowadays, Bowersox lives in Portland, Ore., with Brian Walker, her husband of 18 months, and her son Tony, 3. She'll be releasing an EP soon. A diabetic who was briefly hospitalized during her *Idol* run, Bowersox, 26, now speaks out about the disease as often as possible. "The wake-up call I had has stuck with me and will for the rest of my life," she says. "I want to be around to see Tony graduate from high school and college and get married."

LACEY BROWN

A preacher's daughter from Texas, Brown was cut in Season 8 after a sing-off but made the Final 12 in Season 9. She signed with Lawrence Music Group, headed by country star Tracy Lawrence, and released an EP, *Let It Go*, in May. In November 2011 Brown, 26, opened for Don Williams, which she described at the time as "a dream come true for a rookie like me … I'm a huge fan!"

LEE DEWYZE

As a great philosopher never said: Sometimes one door opens, then closes, then another door opens *while the first one is reopening.* Or . . . something. Season 9's winner was signed, released an album, *Live It Up,* and, when sales proved disappointing, was dropped from his label. On the other hand (in a big way): While shooting a video for his song "Sweet Serendipity," DeWyze met and fell for model-actress Jonna Walsh, and they're getting married later this year. "It just felt right, you know?" says DeWyze, 26. "I always thought, I don't know if I'll ever get married, but then I met her and that was that. I love her because she's talented, she's driven. She has goals for herself and she's just an amazing person to talk to and be with."

Musically, he's already focusing on his next album, due this year. "The sound is folk, pop and country all wrapped into one—a little Mumford & Sons meets Keith Urban meets folk. I've always been more of a folk-based singer-songwriter. I'm looking forward to getting back on the road and playing and seeing fans." His *Idol* thoughts? "It changed everything," says DeWyze. "It's really allowed me to do this for a living, so it has been a blessing. I'm happy to have gone through that experience and come out the other side alive, you know?"

TIM URBAN

"*American Idol* was the biggest emotional roller coaster, so many highs and lows," the Texas native told the *Litchefield County Times*. Nicknamed "Teflon Tim" for his ability to survive despite often getting spanked by judges, his making it to the Final 12 was another small miracle: Urban was cut but given a reprieve when contestant Chris Golightly was disqualified for fibbing about a prior record deal. Urban released a YouTube video of Adele's "Someone Like You" at the start of 2012, but, for the moment, is focusing on acting. "I'm shooting one movie [a military drama, based on a true story] in March, then another [about a musician] after that one wraps." *Idol* lessons? "Understanding how to work with the audience, and a lot about not being so nervous."

MICHAEL LYNCHE

Since leaving in the No. 4 spot, "Big Mike" Lynche, known for making Kara DioGuardi cry with his rendition of "This Woman's Work" and being the recipient of Season 9's "judge's save," has signed a deal with Big 3 records and been working on his album. "I feel like I've been working on it forever and written so many songs," says Lynche, 28. "I haven't titled it yet but it really speaks to the things most important in my life." Those would include wife Christa, daughter Laila, born during his *Idol* season and now 2, and son Kingston, born Feb. 22, 2012. "The best part of life after *Idol* has been Christa and Laila getting to travel everywhere with me," he says. "We couldn't be happier." In fact, he wants to share that happiness: He's shopping a reality TV show based on their lives. He'll also be working with FOX NY, commenting on this season's *Idol* competition.

SIOBHAN MAGNUS

The lifelong "big goober fan" of Hanson (she has the tattoo to prove it!) got to sing with her idols in L.A. and just released her debut album, *Moonbaby*: "It's exciting because I've been working on it so long." She and her boyfriend split time between the Boston area and Nashville and, for fun, "make up sad Smiths songs and sing them" to their cat Morrissey.

CASEY JAMES

Heartthrob looks and a hot guitar helped push the Texan to a third-place finish. From the sound of things, he hasn't stopped grinning since. "It was awesome," says James. "You're experiencing things you've never imagined. First-time experiences day after day—red carpets, interviews, national TV. Unbelievable. It holds a special place in my heart." And it just keeps going: Since leaving *Idol*, James has signed with Sony Music Nashville, opened for Sugarland and sung at the Opry. His self-titled first album came out in March. "I've gotten to take the time to make the album that I wanted to make and I feel like it came out right," says Casey, 29. "I cowrote all the songs except two." He feels lucky that he appeared during a season when *Idol* seemed to focus on singers who also played instruments: "If they didn't allow that to happen, I would've never even auditioned. I don't consider myself a great singer by any stretch." So, will the guy who famously took off his shirt during his audition be incorporating that move into his act? "No! If somebody wants to see it, they can replay it on YouTube. It's probably going downhill from there anyway!"

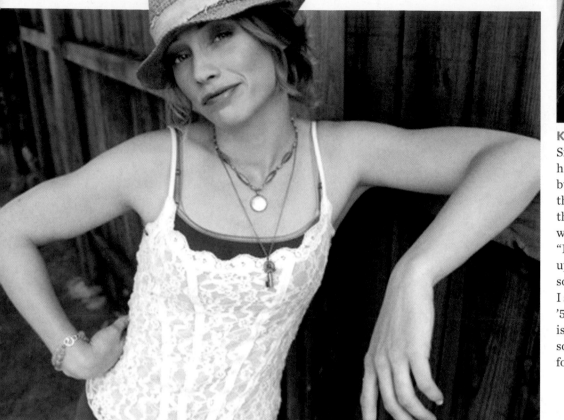

KATIE STEVENS

Since leaving *Idol*, "there have been ups and downs, but at this point I've found the direction of the music that I feel fits my sound and who I am," says Stevens, 19. "I'm an old soul and grew up singing soulful music, so I'm doing soulful pop. I should've been born in the '50s!" She moved to L.A. and is taking acting classes: "I'm so excited to be auditioning for the pilot season!"

DIDI BENAMI

The former waitress learned a lot about the power of TV after giving a rousing performance of judge Kara DioGuardi's song "Terrified," and also shedding tears, on air, while talking about the death of her best friend in a car wreck. "All of a sudden people were like, 'You're the "Terrified" girl! And you're the one who cries a lot!' It was like, 'Oh, my gosh, is this how people really see me?' How do I change that?" Now she's taking acting classes in L.A. ("I've had a couple of callbacks") and working on an album she wants to be "110 percent proud of. I'm trying to capture a new side of me that [fans] didn't know before."

ANDREW GARCIA

"I have a group of friends, and we put together a group called YTF," says Season 9's No. 9 finisher. "We have comedians, dancers and musicians. I'm performing my music, and we throw in some covers here and there." Garcia, 26, who released a single, "Crazy," in 2011, says he's in the studio getting "that right sound" for an album. He and his fiancée, Christine Concepcion, have a son, Caeland. "He is doing amazing," says Garcia. "He'll sing a theme song from a TV show and he's right on key. At 3 1/2, he has perfect pitch!"

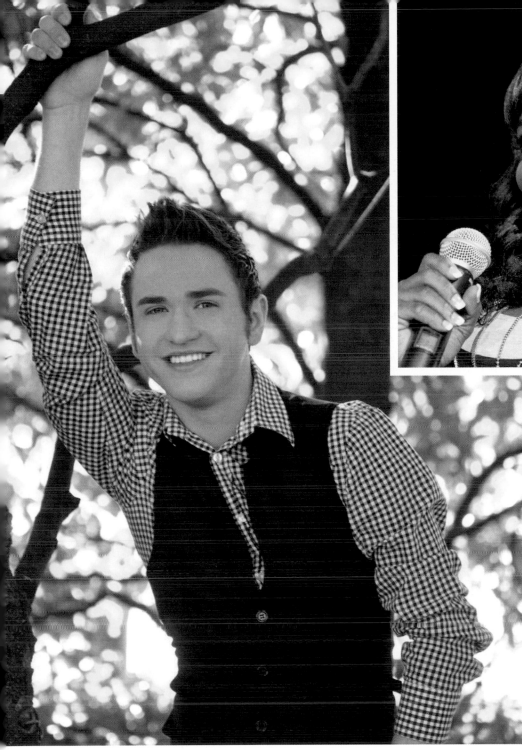

PAIGE MILES

After *Idol*, "I started working with Grammy-nominated producer Mack McKinney and I was able to record my first EP," says the Naples, Fla., native. "So that was a lot of fun. Then I starred in *Beehive*, a musical, in Naples. I got to sing songs like 'River Deep, Mountain High' and 'Natural Woman,' and it was such a great experience. Then I got back to L.A. and started working with Later Days, a rock band." They landed a song, "Affair W/The Industry," on *Kourtney & Kim Take New York*. Watching *Idol* now, says Miles, 26, she and her castmates get "just as nervous as the kids who go through it because we know what it feels like up there. It's weird, the way we feel when we hear that noise that comes on right before Ryan gets to tell you, 'You are going home.' It doesn't matter if you're not up there—that still makes us all want to barf! I could be in the kitchen and hear it and my heart sinks!"

AARON KELLY

The Pennsylvania teen parlayed a one-night win at Disney's American Idol Experience into a place in the front of the audition line, and has been riding his good fortune ever since. Signed with CAA, Kelly released a holiday single, "I Can't Wait for Christmas," and is living in Nashville and working on his album. "The reason it's taken me so long is it's such an important piece of the puzzle of my career," says Kelly, 19. "Every song I put on the album has to be 'it.'" A country-star wannabe, he has been an opening act for Travis Tritt and Little Big Town and has sold out shows on his own in Pennsylvania. "It just feels so good to draw people and have my own fan base," he says. "*Idol* has given me that opportunity." And yes, fans still call him by his *Idol* nickname, Yoda: "I'm actually looking at this huge Yoda doll that somebody gave me right now!"

J.LO

Season 10 contestants probably got hives when they learned they'd be judged by a star with a diva rep and glittery music, movie and fashion credits. But instead of a glamor-puss queen eager to chop off heads, hopefuls encountered a hanky-wringing cheerleader who became so upset when a performer she felt deserved better was eliminated, she soaked the shirts of her fellow judges with her tears.

Surprised? Jennifer Lopez says you shouldn't be: "This is the first time I've done something where people are getting to see my personality," she told PEOPLE. As for her relationship with her fellow judges, it's just ducky: "We just hit it off right away," she said to *Rolling Stone.* "We've become like brothers and sisters." Even her beep-prone sidekick, the guy with the long, wavy hair and pretzel-logic critiques? Yep, him too: "He's a very deep and soulful person," Lopez, 42, says of Steven Tyler, "the crazy mixed in with that is a beautiful combination."

In fact, the only discordant note, for Lopez, may be a personal one: Ten months into her *Idol* tenure, she and Marc Anthony, her husband of seven years, announced they were divorcing.

RELAUNCH

With Simon gone, *Idol* took a risk and found an odd new chemistry

STEVEN TYLER

If the feather-festooned hair and six-gun shades weren't enough to give him away, the words tumbling out of his Stones-logo mouth would make it impossible to not pick the rock star out of the new lineup at the judges table. "I'm very high," the oxygen-supply-depleting Aerosmith icon, 64, told PEOPLE about his biweekly *Idol* fix. "If you think going out in front of high-def cameras and millions of people, I'm not high on adrenaline, you're crazy."

The rocker, whose residence brought a new rush of excitement to the show, hooked *Idol* fans with his unexpected warmth and compassion. "That's who I am," he told PEOPLE. "I'm so proud the world is seeing the daddy that sang to my kids." Lest longtime fans fear that he's suppressed his famously fractured way of expressing himself for *Idol*'s cameras, he added, "I was a little afraid [at first]. I didn't know whether America was just in love with Simon putting people down and seeing blood spurt from the neck of some kid. I wanted to make compassion the new black."

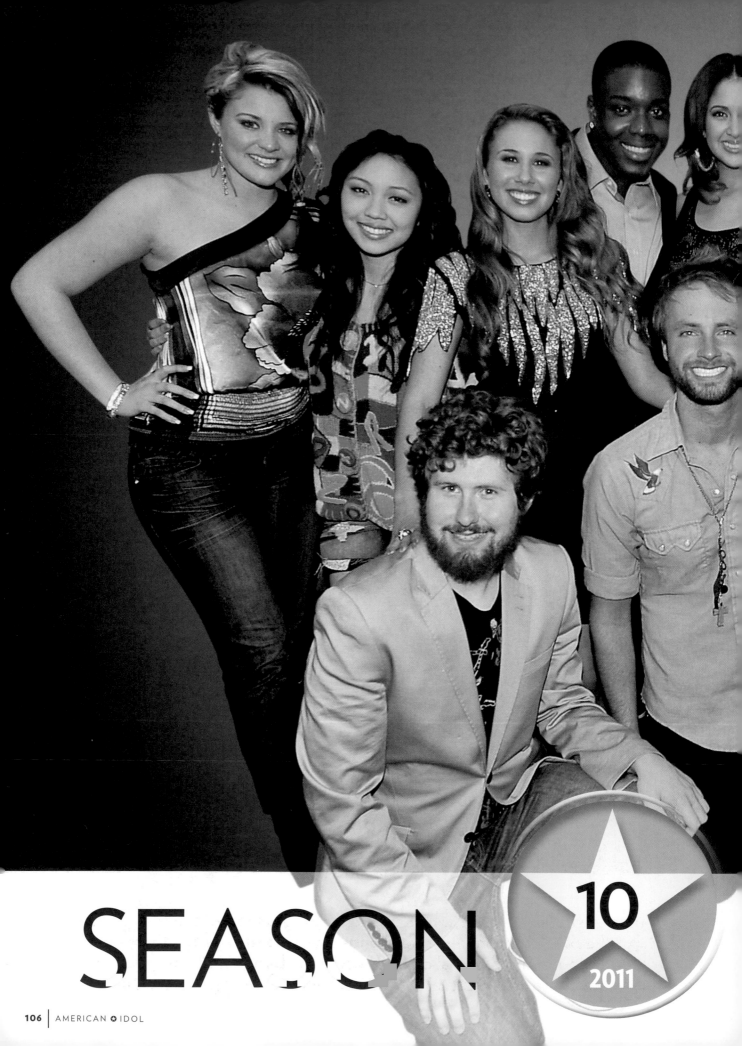

SEASON

10
2011

While fans were tuned to the new mashup at the judges table—"Walk This Way, Jenny from the Block" anyone?—a rule change lowering the age to 15 was good news for Thia Megia, and the final came down to the battle of the high-school juniors, Lauren Alaina and eventual winner Scotty McCreery (see page 24).

LAUREN ALAINA

A cute-as-a-button 16-year-old when she bowed to winner Scotty McCreery, the Rossville, Ga., peach saw her debut album, *Wildflower*, reach No. 5 on Billboard's country chart. Which is pretty remarkable, given the race to get it out. "I went on the *Idol* tour, and recorded during my off days," she says. "It was pretty crazy. I was performing, doing meet-and-greets until midnight and then getting up the next morning to record." Her favorite *Idol* memory, she says, was "the finale, singing with Carrie Underwood. That was awesome. *She's* awesome! I've talked to her quite a few times. If anybody knows what I'm going through, it's Carrie." Since *Idol*, Alaina has lost 25 lbs. through diet and exercise: "It's really about me feeling the best that I possibly can." And, maybe, just a bit more grown-up: "It feels good to outgrow poofy dresses and wear some form-fitting stuff!" In her heart, though, she's still a wide-eyed fan: Running into Miranda Lambert in Nashville, she says, "I almost passed out. I was just so doggone nervous."

PAUL McDONALD

"I had to whip my brain back into shape to hang with all the kids," the quirky country rocker says of the gearshifting needed when he stepped away from his band Grand Magnolias to audition for *Idol*. The detour led to a career-making spot on the finalists' tour—and a dream date at the altar. Newly anointed by his *Idol* fame, McDonald was walking the red carpet at a Hollywood premiere last March when he met *Twilight* actress Nikki Reed; by June they were engaged, and in October they wed. "It's been a whirlwind for sure," he says of his eventful *Idol* year. "Meeting my wife was the main prize—it was a kind of fate!"

JAMES DURBIN

A wedding in the woods—with light sabers? For Durbin, the heavy-metal misfit who didn't let his double-whammy afflictions—he has both Tourette's and Asperger's syndromes—slow him down, Jedi-themed nuptials are par for his consciously off-kilter course.

Durbin capped a busy post-*Idol* year by releasing his debut album, *Memories of a Beautiful Disaster*, and marrying Heidi, his longtime girlfriend and mother of their son Hunter, 2, in a California redwood forest on New Year's Eve. He also appeared in a documentary, *Different Is the New Normal*, about Tourette's, a neurological condition that caused emotional problems throughout his childhood. "People used to spend their lives wanting to be normal, wanting to be popular," he tells PEOPLE. "But for me, after being bullied and teased throughout elementary school, middle school and high school, I didn't want to be like the 'normal' kids. I am damn proud to be different."

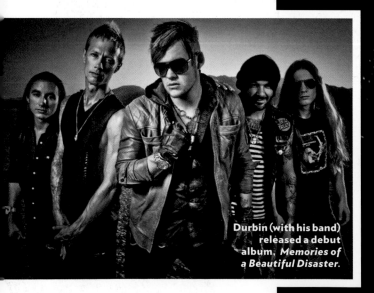

Durbin (with his band) released a debut album, *Memories of a Beautiful Disaster*.

JACOB LUSK

The R&B singer, currently managed by a music "legend and her husband" he won't name on the record, is working on an album. "I think people are gonna be surprised," he says. "I'm gonna do those earth-shattering ballads, but there's gonna be some light stuff as well." He also has movie ambitions: "I'm gonna have a Jennifer Hudson moment!" Nothing if not positive, Lusk, 24, says his ATM PIN includes the letters OGOG— for Oscar, Grammy, Oscar, Grammy.

NAIMA ADEDAPO

"It was very difficult being away from them," says the onetime Milwaukee janitor and full-time mother of two young daughters. Luckily for the singer, whose reggae-flavored vocal style won her a wild card spot in the Top 13, her husband, Jah Dwayne Tafari, cheers her success—she launches her solo career in March with a three-song EP— even as it increases his child care duties. "He has been my rock," she says of Tafari, who is in for a surprise when he reads this. "I want to have one more kid," she says. "He doesn't know that yet!"

STEFANO LANGONE

The crooner, signed by Hollywood Records, knew he had a strong Latin following but was surprised to learn fans weren't passionate only about his music. "I was [named] one of the Top 25 hottest Latin stars," he says of a magazine's assessment. "There aren't many Latin male pop stars under 25," he notes. "I can really take the reins on that!"

PIA TOSCANO

The New York-born powerhouse is a lesson in persistence: She auditioned for *Idol* four times before making it through—perhaps because one notable roadblock was absent. "Simon was always the one who eliminated me!" she says. Her exit, at No. 9, shocked many viewers, but Toscano, 23, was quickly signed by Interscope and will have an album out this year. On the romance front, she briefly dated *Dancing with the Stars* pro Mark Ballas (the press coverage "was a lot to get used to") but is back in the single lane: "I'm 110 percent dating my music right now—I'm not in a relationship."

CASEY ABRAMS

Signed by Concord Records, Abrams did what a jazz guy should do: He improvised, writing a song called "I Got Signed," then made a video and posted it on his website. His theory: "Why *not* announce it in the weirdest way possible?" Abrams has released a holiday single "Baby It's Cold Outside" with pal Haley Reinhart, and hopes to have his first album out this year ("I'm trying to come up with weird concepts and weird chord changes"). His main *Idol* memories? "I was so happy to be next to James Durbin, who made metal cool on *Idol,* and Jacob Lusk, who brought us all to church with gospel, and Naima, who brought reggae-soul flavor. I was glad to bring in the upright bass." He finds it fun to be recognized, though he says he's often mistaken for "the *Hangover* guy—I look exactly like Zach Galifianakis."

THIA MEGIA

Idol's youngest-ever contestant—15 when she stepped onstage—is still just a junior in high school, working on creating her first album. "A lot of people said that I was really poised for 15," she says, "but the truth is, it was crazy and stressful. But if I could do it again for fun, I would." P.S.: Those rumors she dated Scotty McCreery? Not true: "Just friends!"

ASHTHON JONES

"I don't want to be put in a box," says the wild card finalist, whose many hats make that fate unlikely. The singer-actress-entrepreneur has an album in the hopper ("It's called *Goodbye Genre*"), is shooting footage for a reality TV project and says she's been offered a film role. For good measure, she launched her own Dirti Pearls entertainment company and is organizing a Nashville scholarship fund-raiser.

HALEY REINHART

"It's been busy—I haven't stopped!" says Reinhart. "It's been the show to the tour and press and now"—thanks to signing with Interscope Records—"my own career! I should have an album out in May." On the Season 10 class's success: "There's eight of us now [who are signed]," she says. "I don't know if Season 11 can top ours—not to be cocky or anything!" Another thrill: Her dad may play guitar a bit on her album, she notes, so, definitely, "I'm movin' on up, you know!"

KAREN RODRIGUEZ

She didn't win, but Rodriguez says she got something else: "I met all the people I need to meet in order for my dreams to start becoming a reality." She's working on an album and will sing in Spanish: "I wanted to represent myself and be the voice of Spanish people everywhere."

IDOL

WILD CARDS

They didn't win, and only one reached the final 12, but they all made headlines nonetheless

FRENCHIE DAVIS

The Season 2 fave with the powerhouse pipes hasn't let an *Idol* scandal slow her down. After getting axed for posing topless when she was 19, Davis has burned up Broadway in *Rent*, scored a dance chart hit "You Are" and—in a bit of sweet redemption—placed fifth on that *other* singing show, *The Voice*. Her self-titled debut album is slated for release later this year.

NICK MITCHELL

The comic actor auditioned in character as cabaret hack Norman Gentle, and—in a bizarre exchange—Simon implied that Gentle probably "quite liked" being kicked between the legs. To which Gentle responded, "The way you like it when Seacrest does it?" The slap-back got him a ticket to Hollywood. Now? Mitchell, as Gentle, became an *Idol* commentator on *The Wendy Williams Show* and appeared in a video, *Bitch Slap*. Mitchell, 32, is now making a pilot for a travel show about New York. His "magical" *Idol* moment, he says, "is affecting me to this day."

GENERAL LARRY PLATT

His ridiculously catchy rap "Pants on the Ground" charmed the judges and quickly went viral (more than 8 million YouTube hits), even though the then 62-year-old was decades over the *Idol* age limit. Platt—who earned his moniker as a civil-rights activist during the '60s—has lately faced health issues, but he continues to be thrilled by his song's appeal. "I'm still around," he says, "and I'm putting more [lyrics] to it now."

WILLIAM HUNG

Idol's most famous fluke turned a tone-deaf take of "She Bangs" into a profitable career that included three albums and TV guest gigs. Now Hung, 29, crunches crime data for the L.A. County Sheriff's Department. "My passion has always been math," he says. "It just took a while to end up as my career." Of *Idol*, he told *L.A. Weekly,* "I showed that an Average Joe could succeed."

KATRINA DARRELL

Season 8's Bikini Girl auditioner capitalized on her moment by making promotional appearances, becoming an *Idol* commentator and "doing celebrity Playboy Bunny blackjack dealing" in Las Vegas. She'll release a single this summer.

REYNALDO LAPUZ

Oddly dressed, he sang his own composition "Brothers Forever" at a Season 7 audition. Paula danced, Randy sang along—yet the panel still nixed him. "Brothers" became a successful ringtone; Lapuz has since released a single, "Christmas Chocolatee," on iTunes.

COREY CLARK

He was booted from Season 2 after hiding a past arrest, but the real scandal sizzled two years later when Clark claimed he was Paula Abdul's "boy toy" during the show. (Abdul denied the relationship.) Since then Clark has had other tangles with the law, but he's now a music major at Middle Tennessee State University and wants to be a "positive role model" for his wife, Monica, and three kids. As for keeping up with the latest season of *Idol*? "I'm making the cognizant choice," he says, "to not add to their ratings."

IDOL

MAKEOVERS

Remade for stardom, some *Idol* grads look nothing like the nervous neophytes we first met

CLAY AIKEN

"I know that I've got big ears, a big forehead and my hair sticks up," said Aiken, whose modesty was a big part of his charm. Then *Idol* went to work, picking clothes, removing his glasses and introducing him to a flatiron for his hair. "I've never burned my fingers but I have burned my ears occasionally," he noted. "I definitely look different now."

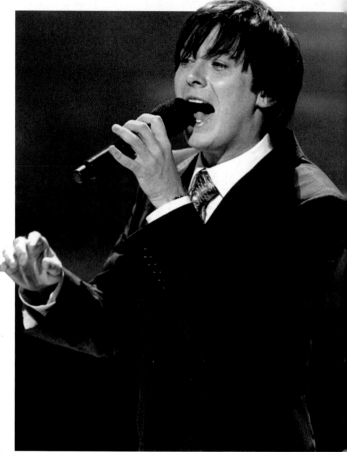

JENNIFER HUDSON

"Some people called me the Big Girl on *Idol*," recalled the Season 3 contender. "But I was a size that made me happy." Later, after gaining 20 lbs. for her role in *Dreamgirls*, losing it, then gaining 35 lbs. while pregnant with her son David Jr. she decided to dedicate herself to getting slim through cardio and diet. "After having my baby, I wanted my body back," says Hudson. "To conquer that challenge is exciting to me."

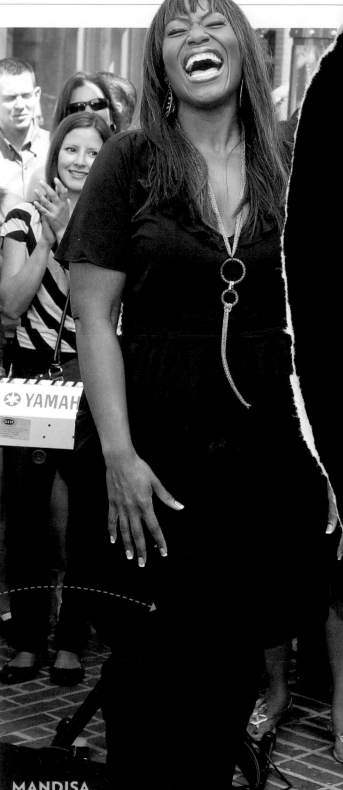

MANDISA

The singer—criticized by Simon for her weight—has lost more than 100 lbs. through diet and exercise. Sexually abused when young, Mandisa, 35, says she now realizes she sought safety in food: "The heavier I got, men weren't looking at me, and that made me feel safe."

JORDIN SPARKS

A 2010 case of walking pneumonia got the Season 6 winner thinking about her health, which led to gradual changes that led, over time, to dramatic results. In addition to cardio workouts, particularly Zumba (a dance regimen), she says, "One of the big things was just portions. 'Do I really *need* another piece? Do I really *want* three servings?'" Sparks, 22, says she's now on better terms with her reflection: "I wasn't devastated when I looked in the mirror, but now I'm like, 'I have a muscle there!' I can see change. Maybe there are a couple of extra seconds that I look now!"

ANWAR ROBINSON

"Having a mane of hair as my largest claim to fame was not my idea of strength," says Robinson, who asked his mom to lop his locks on his 30th birthday in 2009. Management worried about recognizability. "I agreed!" he says, but, "it was more important to me to progress on a personal and spiritual level."

WEDDINGS

Goin' to the chapel: Pouring their hearts into real-life love songs, these finalists found harmony

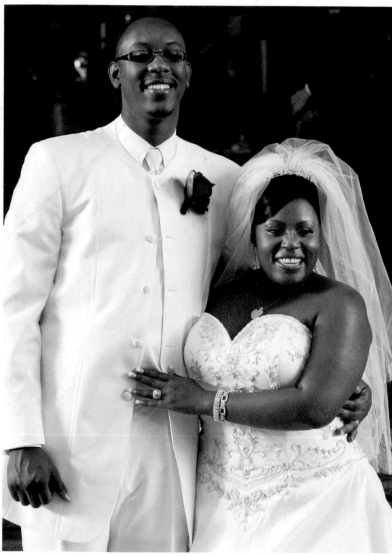

LAKISHA JONES
When the Season 6 finalist and financial adviser Larry Davis said "I do" in Beverly Hills in 2008, four *Idol*-mates were there to sing harmony. "He lets me be me," Jones said. "After the shows are done, the wigs come off, the eyelashes come off and this is me," she says. "And does he still love this girl? He does!"

KATHARINE MCPHEE
The singer-actress and her longtime love, Nick Cokas, wed in 2008 in Beverly Hills. McPhee, wearing $250,000 worth of Neil Lane jewels, serenaded her groom and 300 guests with the song "Unforgettable."

DANNY GOKEY
The Season 8 finalist, whose first wife passed away in 2008, married Leyicet Peralta in Coral Gables, Fla., in February. Now, he says, "There's love and hope."

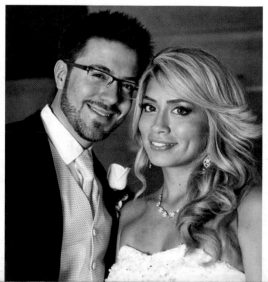

LEE DEWYZE

Fan worship used to make the pompadoured former paint salesman and Season 9 champ blush. "I saw a girl crying," he said of a besotted fan. "I was like, 'It's okay, I'm not that cool.'" He maintained the everyman image when he talked about what he was looking for in an ideal mate: She would like to cook, he said, not wear too much makeup and be honest "even [when] the truth hurts." Last summer the Idol King announced he'd found his queen: He and model-actress Jonna Walsh plan to marry this fall. "When you know, you know," he said.

SCOTT MacINTYRE

Severe tunnel vision that made him legally blind and forced him to look at the world as if "through a coffee straw" did not stop him from reaching *Idol's* finals in Season 8, wowing fans like Oscar winner Diablo Cody ("In a world of wannabe Jonas Brothers, it's refreshing to see a guy who'd rather be Art Garfunkel"). He and longtime girlfriend Christina Teich wed last August.

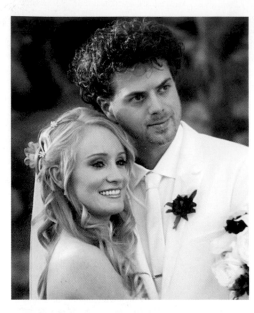

MEGAN JOY

Among her tattoos was a "mystery man," said the Season 8 fave, whose country licks and twitchy hips seemed to mesmerize Simon as well as millions of viewers. "I'm still looking for him." Not anymore! Joy, 26, who has a son, Ryder, from a previous marriage, wed Quinn Allman, guitarist for the Utah-based alt-rock band The Used, last summer.

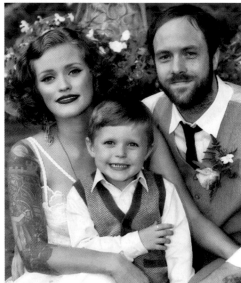

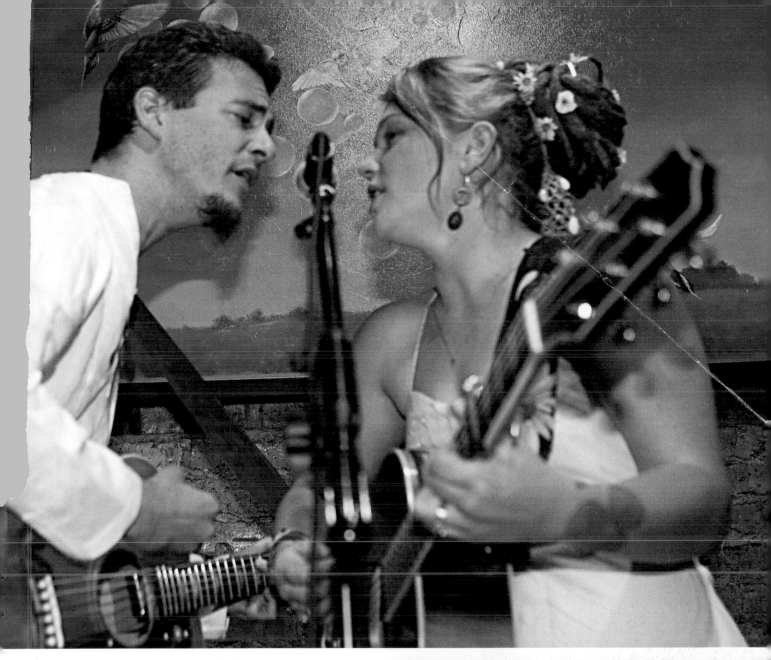

CRYSTAL BOWERSOX

We knew the bride when she used to rock and roll. And nothing's changed for the single mom and roots rocker who wore a hemp-and-cotton bridal gown and kicked out the jams with her guitar pickin' longtime boyfriend, Brian Walker, at the Chicago cafe where they met— and where they wed in 2010.

JAMES DURBIN

"I was flabbergasted," said the groom. "I cried a ton." And that was *before* the Season 10 finalist, famous for overcoming Tourette's and Asperger's syndromes to finish fourth, exchanged vows with Heidi Lowe in 2011. "I can't describe how much I love her," he said. "But now we're married, so I can show it!"

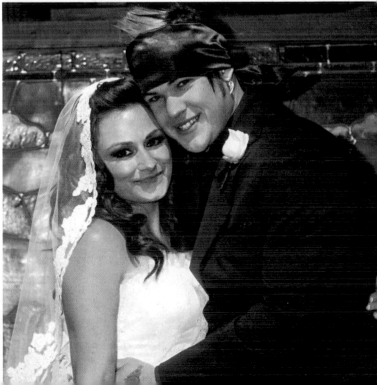

BY THE NUMBERS

How to measure the 10-year impact of *American Idol*? Let's do the math

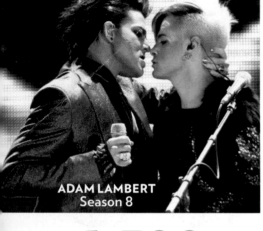

ADAM LAMBERT
Season 8

9

FINALISTS WHO
ARE PUBLISHED
AUTHORS*
(including one e-book)

SANJAYA MALAKAR
Season 6

**CARRIE
UNDERWOOD**
Season 4

1,500

Approximate number of complaints
received by ABC after Adam
Lambert's racy performance at the
2009 American Music Awards

12,505,000

**TOTAL NUMBER OF
ALBUMS SOLD
BY CARRIE UNDERWOOD**
The most of any finalist
(courtesy Nielsen SoundScan)

5

FINALISTS WITH
HEADLINE-MAKING
POST-*IDOL* ARRESTS*

COREY CLARK
Season 2

RUBIN STUDDARD
Season 2

23

FINALISTS
WHO HAVE RELEASED
CHRISTMAS MUSIC*

1

NUMBER OF IDOLS WHO HAVE THEIR
OWN FRAGRANCE

**JORDIN
SPARKS**
Season 6

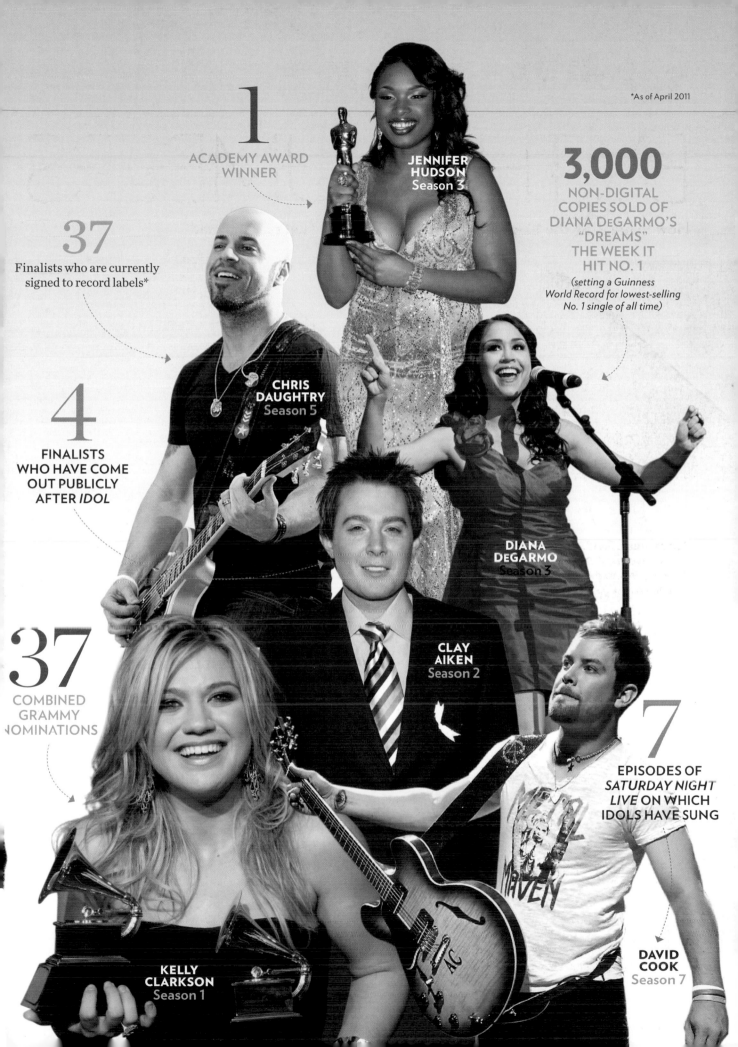

1
ACADEMY AWARD
WINNER

*As of April 2011

3,000
NON-DIGITAL
COPIES SOLD OF
DIANA DeGARMO'S
"DREAMS"
THE WEEK IT
HIT NO. 1
*(setting a Guinness
World Record for lowest-selling
No. 1 single of all time)*

37
Finalists who are currently
signed to record labels*

**JENNIFER
HUDSON**
Season 3

**CHRIS
DAUGHTRY**
Season 5

4
FINALISTS
WHO HAVE COME
OUT PUBLICLY
AFTER *IDOL*

**DIANA
DeGARMO**
Season 3

**CLAY
AIKEN**
Season 2

37
COMBINED
GRAMMY
NOMINATIONS

7
EPISODES OF
*SATURDAY NIGHT
LIVE* ON WHICH
IDOLS HAVE SUNG

**KELLY
CLARKSON**
Season 1

**DAVID
COOK**
Season 7

IDOL **CREDITS**

Editor Cutler Durkee **Design Director** Andrea Dunham **Photo Director** Chris Dougherty **Photo Editor** C.Tiffany Lee-Ramos **Art Director** Cynthia Rhett **Designer** Joan Dorney **Writer** Steve Dougherty **Writer/Reporter** Ellen Shapiro **Copy Editor** Will Becker **Scanners** Brien Foy, Stephen Pabarue **Group Imaging Director** Francis Fitzgerald **Imaging Manager** Rob Roszkowski **Imaging Production Manager** Romeo Cifelli, Charles Guardino **Imaging Coordinator** Jeff Ingledue

Special thanks: Céline Wojtala, David Barbee, Jane Bealer, Patricia Clark, Margery Frohlinger, Suzy Im, Ean Sheehy, Patrick Yang

TIME HOME ENTERTAINMENT
Publisher Richard Fraiman **Vice President, Business Development & Strategy** Steven Sandonato **Executive Director, Marketing Services** Carol Pittard **Executive Director, Retail & Special Sales** Tom Mifsud **Executive Publishing Director** Joy Butts **Director, Bookazine Development & Marketing** Laura Adam **Finance Director** Glenn Buonocore **Assistant General Counsel** Helen Wan **Assistant Director, Special Sales** Ilene Schreider **Design & Prepress Manager** Anne-Michelle Gallero **Brand Manager** Michela Wilde **Associate Brand Manager** Isata Yansaneh **Associate Production Manager** Kimberly Marshall **Editorial Director** Stephen Koepp **Special thanks:** Christine Austin, Katherine Barnet, Jeremy Biloon, Jim Childs, Susan Chodakiewicz, Rose Cirrincione, Lauren Hall Clark, Jacqueline Fitzgerald, Christine Font, Jenna Goldberg, Hillary Hirsch, Suzanne Janso, Amy Mangus, Robert Marasco, Amy Migliaccio, Nina Mistry, Dave Rozzelle, Adriana Tierno, Alex Voznesenskiy, Vanessa Wu

FRONT COVER
(clockwise from top right) Frank Micelotta/PictureGroup; Robert Galbraith/Reuters; Girlie/FameFlynet; Anders Overgaard/Trunk Archive; Frank Micelotta/PictureGroup; Jennifer Graylock/AP; Kevin Winter/Getty Images; Cliff Lipson/CBS/Landov

CONTENTS
2-3 (from left) Alexander Noe; Michael Yarish/FOX; John M. Heller/Getty Images; Walter McBride/Retna; Ray Mickshaw/FOX; Kevin Mazur/Wireimage

IDOL RICH
4-5 (from left) Ray Mickshaw/FOX; Anders Overgaard/Trunk Archive; Evan Klanfer/CPi; Girlie/FameFlynet; Ethan Miller/Getty Images; **6** Kristin Callahan/Everett; **7** Katy Winn/Corbis; **8** Jason Moore/Zuma/Corbis; **9** (from top) Ray Mickshaw/FOX; Larry Busacca/Getty Images; **10-11** (from left) Jeff Lipsky/CPi; Ray Mickshaw/FOX; **12-13** (from left) Anthony Mandler/Corbis Outline; Ray Mickshaw/FOX; **14-15** (from left) Casey Rodgers/Corbis Outline; Ray Mickshaw/Wireimage; **16-17** (from left) Timothy White/Corbis Outline; Michael Yarish/FOX; **18-19** (from left) Joe Buissink; Ray Mickshaw/Wireimage; **20-21** (from top) MR Photo/Corbis Outline; Ray Mickshaw/FOX; **22-23** (from left) Alexander Noe; FOX; **24** Brian Doben; **25** Mark Seliger/NBC; **26** Pat Greenhouse/Boston Globe/Getty Images; **27** Curtis Brown

JUDGES
28-29 Michael Elins/Corbis Outline; **30** Jason Bell/Camera Press/Redux; **31** Ian Derry/FOX; **32-33** A. Rapoport/FOX; **34** (clockwise from right) Kristian Dowling/PictureGroup; Ray Mickshaw/Wireimage; **35** Joe Pugliese/Corbis Outline; **36** Eric Cahan/Corbis Outline; **37** Michael Becker/FOX; (inset) Shutterstock

WHERE ARE THEY NOW?
38-39 (from left) J.Viles/FOX; FOX; Zuma; Ray Mickshaw/Wireimage(2); Frank Micelotta/PictureGroup; Marc Hom; Chris Cuffaro/FOX; Harper Smith; 19 Entertainment; **40-41** FOX; **42** Paul Kolnik; (inset) J.Viles/FOX; **43** (from top) Tammie Arroyo/AFF-USA; Stephanie Harms; **44** (clockwise from top left) Dennis Van Tine/LFI; J.Viles/FOX(2); Courtesy Ryan Starr; **45** (clockwise from top right) Scott Downie/Celebrity Photo; Kristy Furg; Angela Swan/JUMPSHOTS; J.Viles/FOX; **46-47** Chris Polk/Filmmagic; **48** Mark Sullivan/Wireimage; (inset) FOX; **49** (from top) Dan Harr/Splash News; FOX; **50** (from left) Owen Beiny/WENN; Ari Michaelson; **51** (clockwise from top left) Holly J. Schumacher; FOX; Michael Manna; Hazen Studios; Lacey Leach; **52-53** Neal Peters Collection; **54** (clockwise from top left) Zuma; Moises De Pena/Wireimage; Tiffany Rose/Wireimage; **55** Courtesy Matt Rogers; **56** Courtesy George Huff(3); **57** (clockwise from top right) Beantown Swing Orchestra; David Livingston/Getty Images; Kenny Ong; Nigel Skeet; Kelly Hobbs; Courtesy Latoya London; Mad Hatter Management(2); **58-59** Ray Mickshaw/FOX; **60** (clockwise from right) Courtesy Anthony Federov(2); Ray Mickshaw/Wireimage; **61** (from top) Courtesy Nikko Smith(2); Michael Bezjian/Wireimage; **62-63** (clockwise from top right) Courtesy Lindsey Cardinale; Mike V. McPherson Jr./UniPhotography; Courtesy Bo Bice(3); Ray Mickshaw/Wireimage; **64** Courtesy Mikalah Gordon; Courtesy Nadia Turner; **65** (clockwise from top left) Larry Busacca/Getty Images; Ray Mickshaw/Wireimage; Courtesy Scott Savol; **66-67** RCA; **68** (from top) Courtesy Taylor Hicks; Lisa Rose; **69** John Cordes/Icon/SMI/Retna; (inset) Joseph Viles/Wireimage; **70** Kristen Barlowe; (inset) Ray Mickshaw/Wireimage; **71** (clockwise from top) Walter McBride/Retna/Corbis; Tony DiMaio/Startracks; Neilson Barnard/Getty Images; Amy Sussman/Getty Images; Walter McBride/Retna/Corbis; **72** Dan Harr/Admedia; **73** (clockwise from top left) Ray Mickshaw/Wireimage; Courtesy Paris Bennett; Melvin Elder, Jr.; FOX; Joshua De La Garza; Beck Starr/Filmmagic; **74-75** Andrew MacPherson/Corbis Outline; **76** (from left) Varela Media; Alex Cao; Alicia Gbur/Sony; **77** (clockwise from top) Courtesy Blake Lewis(2); Cash Money Records; Michael Buckner/Getty Images; **78** (top, clockwise from top left) Courtesy Sanjaya Malakar; Frank Micelotta/PictureGroup; Frank Micelotta/FOX; Frank Micelotta/PictureGroup; Frank Micelotta/FOX; Jordan Strauss/Wireimage; Fred Prouser/Reuters/Corbis; **78** (bottom, from left) Micah Kandros Design; Courtesy Haley Scarnato; Courtesy Gina Ruzicka; Courtesy Chris Sligh; **79** (clockwise from top left) Mary Alice Duncan; FOX; Jory Cordy; FOX; **80-81** FOX; **82-83** (clockwise from top left) Matt Clayton; Todd Owyoung/Startracks; Jake Trott/RCA; Ricky Middlesworth(2); **84** (from top) Angela Kohler; Allen Berezovsky/Meet The Famous; **85** (clockwise from top) Marc Hom; Courtesy Jason Castro; Mark Sullivan/Wireimage; Mike Allen; **86** Julie Aucoin©Cirque du Soleil; **87** (from left) Mark Tucker; Sthanlee B.Mirador/Shooting Star; Courtesy Amanda Overmyer; **88-89** FOX; **90-91** (clockwise from right) Kaitlyn Whitman/Photo Love Photography; Prince Williams/Filmmagic; Courtesy Lil Rounds; **92-93** (clockwise from top left) Courtesy Chris Hollo/Hollo Photographics; Jonathan Leibson/Filmmagic; Michael Becker/FOX; Courtesy Michael Sarver; Jenn Cady; **94** (from top) Joseph Tran; Courtesy Scott MacIntyre; **95** (clockwise from top left) Curtis Hilbun/AFF-USA; Courtesy Alexis Grace(2); Michael Becker/FOX; **96-97** Michael Becker/PictureGroup; **98** (from top) Dan Harr/AdMedia; Joseph Elliott; **99** Allen Berezovsky/Filmmagic; **100** (clockwise from top left) Ouzounova/Splash News; Jason Angelini; Rowland Scherman; **101** James Minchin; **102** (clockwise from top left) Teddy Saunders; Joe Stevens/Retna; Tommy Su/SnapIt Studio; **103** (from left) Price Stone; Paul Hebert/Corbis; **104** Warwick Saint/FOX; **105** Andrew MacPherson/Corbis Outline; **106-107** Mark Davis/PictureGroup; **108** Brian Bowen Smith; **109** Courtesy Paul McDonald; **110** (from left) Nikola Dupkanic; Michael Scott Slosar; **111** (clockwise from top left) Lexion Photo; 19 Entertainment(2); Courtesy Naima Adedapo; **112** 19 Entertainment; **113** (clockwise from top left) IOS/London Ent/Splash News; Courtesy Ashthon Jones; Jeff Frank/Zuma; 19 Entertainment

WILD CARDS
114 (from left) Clinton Wallace/Globe/Zuma; Sthanlee B. Mirador/Shooting Star; **115** Michael Becker/PictureGroup; (inset) TMZ/Splash News; **116** (from left) Michael Becker/Getty Images; Michael Becker/FOX; **117** Jim Warren

MAKEOVERS
118 (clockwise from top right) Kevork Djansezian/AP; Adam Orchon/Retna; Henry McGee/Globe; Fitzroy Barrett/Globe; Albert Ferreira/Startracks; Jeff Kravitz/Filmmagic; **119** (from left) Ray Mickshaw/Wireimage; Sthanlee B. Mirador/Shooting Star; **120** (from left) Noel Vasquez/Getty Images; Ray Mickshaw/FOX; **121** (clockwise from top right) Andrew MacPherson/Corbis Outline; Shon Richards; FOX

WEDDINGS
122 (clockwise from top left) Flynet; Berliner Studio; Complete Music/Video/Photo Nashville; **123** Kristina Carter; **124** (clockwise from left) Courtesy Lee Dewyze; Bozeman Media; Pepper Nix; **125** (from top) Bob Berg; James Everett

BY THE NUMBERS
126 (heads, clockwise from top left) Matt Sayles/AP; Michael Loccisano/Wireimage; Sara Jaye Weiss/Startraks; Yuma County Sheriff Dept.; Jen Lowery/LFI; (wreath) BrandX/Getty Images; (perfume) Alex Cao; **127** (clockwise from top left) Mr.Black/Startracks; Gilbert Flores/Celebrity Photo; Ben Rose/Wireimage; WENN; Robert Galbraith/Reuters; Dimitrios Kambouris/Wireimage

BACK COVER
(clockwise from left) A.Rapoport/FOX; Lisa Rose; Ray Mickshaw/Wireimage; WENN; Joseph Viles/Wireimage; Larry Marano/Getty Images; Warwick Saint/FOX